BLACK AMERICA SERIES
SAVANNAH
GEORGIA

Charles J. Elmore

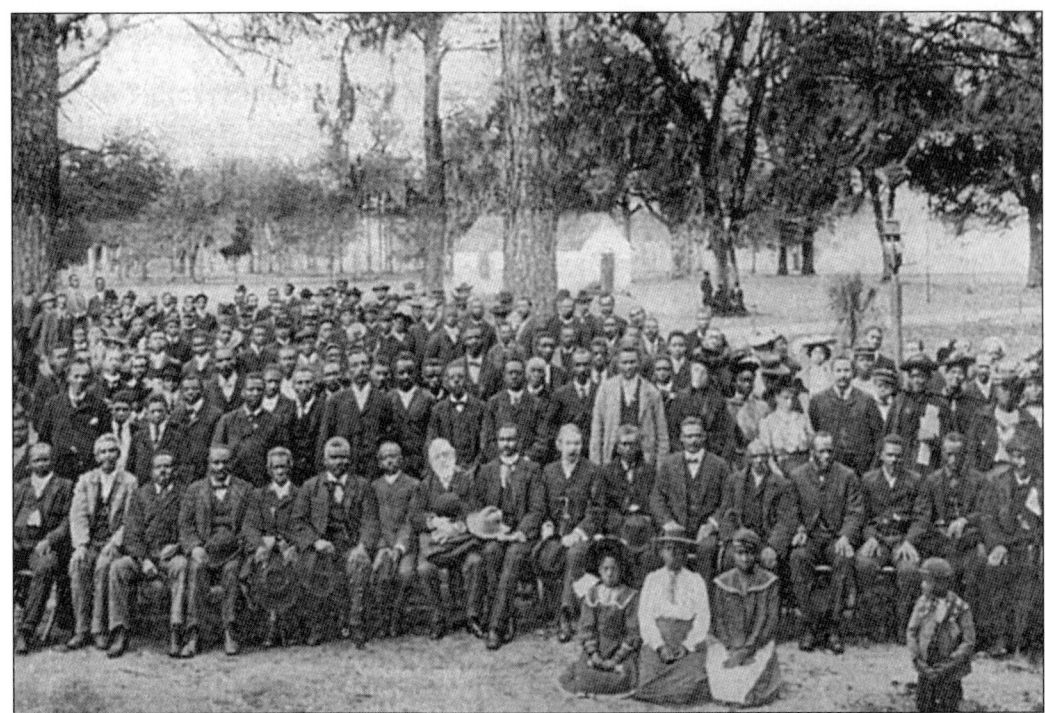

The 1903 Farmers Conference at Georgia State Industrial College (GSIC) was attended by the school's president, Richard R. Wright Sr. (front row, seventh from the left) and George Washington Carver (hat in lap, ninth person from the left). President Wright held 20 Farmers Conferences during his 30 years as GSIC president (1891–1921). (Courtesy of Savannah State University Archives.)

(*on the front cover*) The Class of 1900 at Georgia State Industrial College included, from left to right, (front row) M.L. Whitmire; Richard R Wright Sr., college president; Decatur Suggs, college vice president; and E.W. Bissard; (back row) J.W. Haigler, F.A. Fields, class vice president; E.W. Houston, class president; Samuel A. Grant, class secretary; Etta McIntosh, class treasurer; and E.A. Overstreet.

(*on the back cover*) This is the Georgia State Industrial College Class of 1901. Pictured from left to right are (front row) Hettie L. Roston, J. Pearl Butler, Hattie Gerrideau, and Rebecca Sengstacke; (middle row) R.R. Holmes, Thomas Baker, Rhina A. Albany, and James M. Washington; (back row) Theodore B. Gordon, Ida Magrante, Lula Smith, W.A. Richie, and Jessie Bradley. Also included in the original picture but not shown in this cropped version are Joseph Ford; Essie W. Wright; Nathan B. Young, professor; and Mamie V. Edwards.

Black America Series
Savannah
Georgia

Charles J. Elmore, Ph.D.

Copyright © 2000 by Charles J. Elmore.
ISBN 0-7385-1408-X

Published by Arcadia Publishing,
an imprint of Tempus Publishing, Inc.
2 Cumberland Street
Charleston, SC 29401

Printed in Great Britain.
Library of Congress Catalog Card Number: 2001095826

For all general information contact Arcadia Publishing at:
Telephone 843-853-2070 Fax 843-853-0044
E-Mail sales@arcadiapublishing.com
For customer service and orders: Toll-Free 1-888-313-2665
Visit us on the internet at http://www.arcadiapublishing.com

Dedication

This book is dedicated with love to Louis Steele and Anna Powell Steele, my great-great grandparents; Willie Elmore, Annie Rebecca Elmore, and Clara Belle Moore, my grandparents; Norman and Pauline Elmore, my parents and first great teachers; Juanita, my wife; and Brandi and Charles, my children. It is dedicated to my siblings—Norman (deceased), Irene, Clara, and Paul; and to Noah Benedict and Simone Marie, the newest members of the Elmore clan. This labor of love is also dedicated to the pioneering families and leaders, their descendants, and those African Americans who continue to improve America and make the American dream a reality.

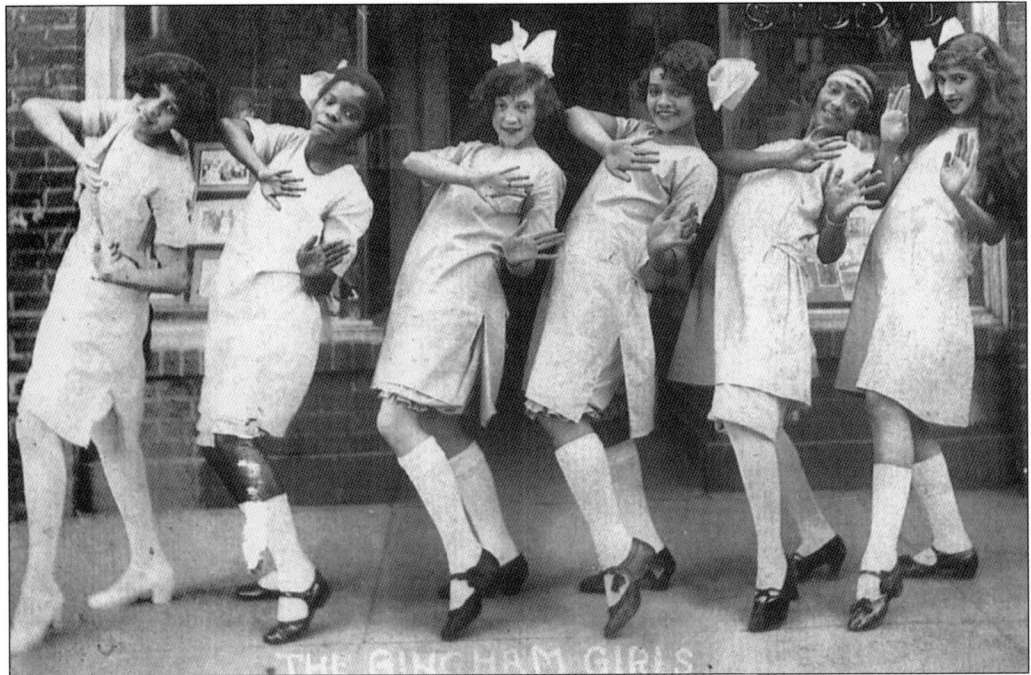

These Beach-Cuyler School students, pictured on May 3, 1925, were known as "The Gingham Girls." From left to right are Kathleen Campbell Thomas, unidentified, Maxine McDew, Mamie King Felder, Nancy Thomas, and Rosemary Curley Jackson Brooks.

CONTENTS

Acknowledgments 6

Introduction 7

1. Pioneers 9

2. The Civil War 27

3. Religion 33

4. Education 49

5. Business 71

6. Medical Pioneers 85

7. Clubs and Jazz 97

8. The Civil Rights Era 117

ACKNOWLEDGMENTS

I am deeply grateful to the Ralph Mark Gilbert Civil Rights Museum and W.W. Law for the use of historic, Civil Rights–era pictures. I received valuable photographs and information from the Savannah State University Archives, and I am grateful to Mary J. Fayoyin, head librarian, and Bridget B. Mullice, archives assistant. I would also like to thank Steve Bisson, chief photographer for the *Savannah Morning News*, and John Carrington for securing rare photographs for this publication. I sincerely thank the following individuals and organizations who assisted with this publication: Harriet Peeler Stone, John R. Stiles Jr., Virginia Edwards, Ursuline Ingersol, Mayor Floyd Adams, Kenneth Adams, Frenchye Bynes, Frank Bynes, William E. Fonvielle, Margaret Gadsden Caution, Lucy Gadsden Solomon, Ouida Thompson, Merdis Lyons, Benjamin F. Lewis, Willie Mae Patterson Freeman, Kana Mutawassim, Roderick Steele Family, John White, Janie Toomer, Louise L. Owens, John B. Clemmons, Mozelle D. Clemmons, Samuel C. Parker Jr., Wolves Club, Inc., James Cobham, Willie G. Tucker, Constance H. Cooper, Teddy Adams, Benjamin Tucker, Pauline E. Elmore, Ann Jordan, Leola Williams, Associate U.S. Supreme Court Justice Clarence Thomas, Orion L. Douglass, Agatha Curley Morris, Ethel King, Otis S. Johnson, John William Jamerson III, Rex DeLoach, Lois Wilson Conyers, Martha Wright Wilson, Asbury United Methodist Church, First Bryan Baptist Church, First African Baptist Church, and Butler Presbyterian Church.

INTRODUCTION

This pictorial history chronicles African-American people who came as slaves to Georgia, one of the 13 original colonies, as early as 1733, and officially, in 1749, when slavery was legally permitted in Georgia. What is extraordinary about the pictures in this book is that they came with enthusiasm from the descendants of those African Americans who *lived* the history of Savannah, from slavery to freedom. From their scrapbooks and precious pictorial memories they gave me the humble opportunity to share an important American story. In short, they liberated a 268-year history of African Americans in all areas of endeavor. Without their generosity and Catholic spirits, this seminal pictorial history could not have been compiled. This work is a labor of love, which examines the pioneer families of Savannah and leaders in the areas of military, education, religion, business, medicine, entertainment, and Civil Rights.

The early history of blacks in Savannah indicates a period of struggle against slavery and inequality in civil and political rights. However, against the barriers of slavery and the reverberations of its aftermath, African Americans rose above intolerance to become literate, own property, and organize churches. They became entrepreneurs, educators, doctors, lawyers, civil rights leaders, and agents of change. It is inspiring to note how African Americans started, in 1788, the oldest continuous black Baptist congregation in America. Moreover, public education was chartered for African Americans in 1878. However, African Americans maintained clandestine schools in Savannah from the early 19th century until Beach Institute opened, in 1867, after the Civil War. Gen. William T. Sherman decreed "Forty Acres and a Mule" in Savannah, after meeting with 20 African-American leaders in January of 1865.

This history delineates how African-American Savannahians excelled in all areas, to include serving in the Civil War, founding the oldest black public college in Georgia in 1890 (now known as Savannah State University), and establishing hospitals for blacks in 1832 and in 1893. An African-American medical presence has been strong in Savannah from the 1870s to present. African Americans pioneered jazz, vaudeville, and entertainment from the "Old One-Hundred" in 1817—before the Civil War—up to the days of freedom. Savannah produced such jazz greats as Tom Turpin, the "Father of Ragtime;" "Trummy" Young; and numerous others. The Civil Rights Movement in Savannah helped change the course of American history.

Much of Savannah's African-American history lies interred in Laurel Grove South Cemetery (1853); the stories are compelling, inspiring, and illuminated in this book. Many slave graves, dating from the 1700s, were transferred to Laurel Grove from the old black burial ground on Whitfield Square.

This volume celebrates the significant African-American contributions to Savannah's development. It is a testament to those who endured, suffered, labored, and persevered so others could make the transition to equality in America. The work done here is an expression of how love, an indomitable spirit, and courage provided inspiration and a legacy for present and future generations. The stories and faces within these pages fill a lost historical niche and document important African-American history heretofore unknown. *Black America: Savannah* explores and remembers a legacy to be cherished and preserved.

One
PIONEERS

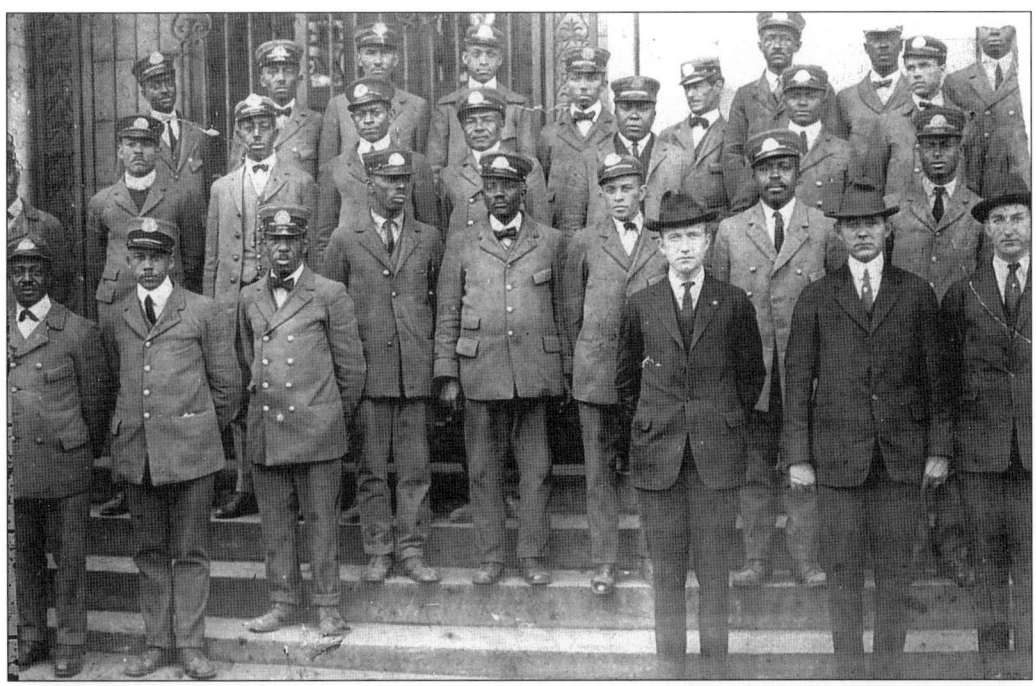

African-American postal workers are pictured in 1923. Seen from left to right are (front row) John Delaware, Joe Parker, Arthur Andrews, Sam King, George White, Dave Parkhurst, C. Burson, and J. P. Lampkin (three men in business suits are unidentified); (middle row) Dickie Stripling, R. Geiger, Fred Alfred, Wilbur Wright, A. Robinson, Tom Harper, and Ezra Johnson; (back row) John McIntosh, M. Bedgood, O. Myer, L. Priester, E. Ashton, Henry Nixon, John Law, and two unidentified. (Courtesy of Samuel C. Parker Jr.)

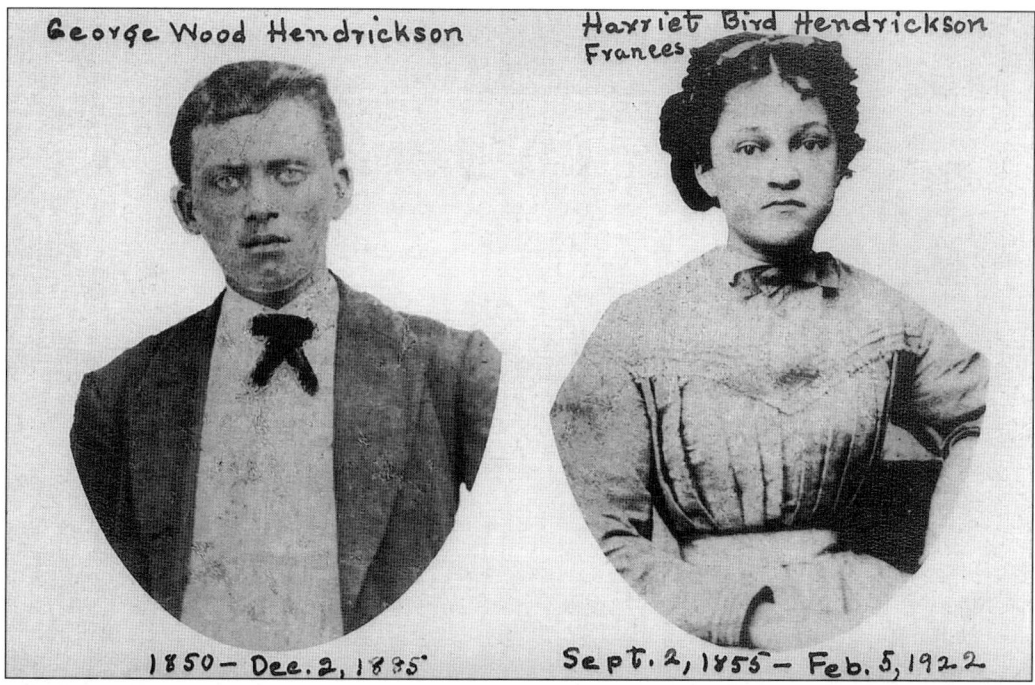

George Wood Hendrickson (b. 1850) married Harriet Frances Bird Hendrickson (b. 1855) during Reconstruction. He was a stevedore on the Savannah docks and she was a seamstress. Harriet Frances Bird worked as a slave on Bird Island in Chatham County, Georgia; hence, her surname was Bird after Bird Island. The Hendricksons were the parents of Constance and Florence Hendrickson. (Courtesy of Harriet P. Stone.)

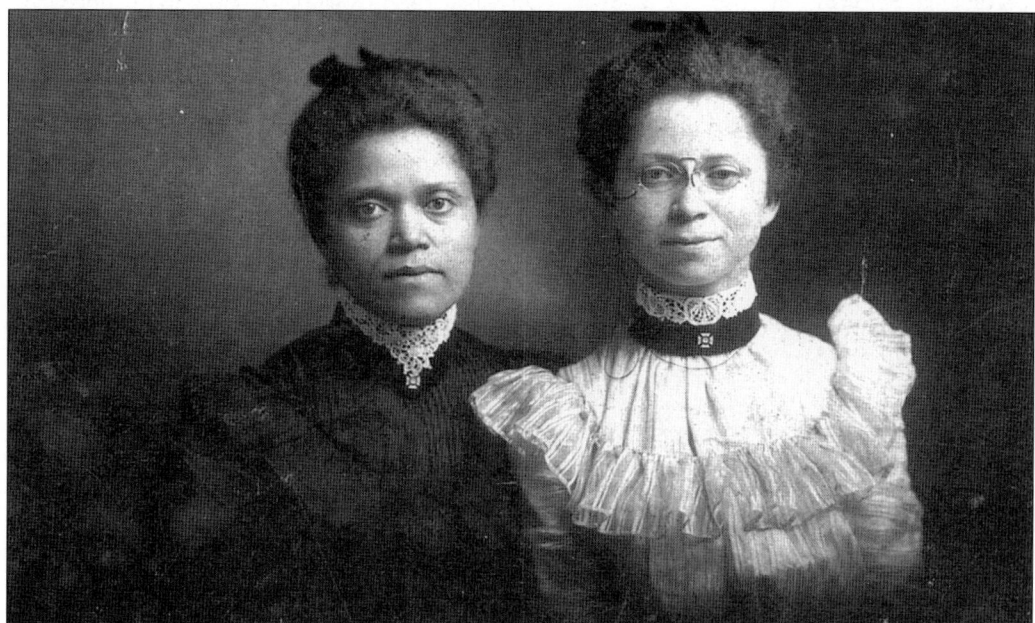

A 1902 photograph shows Constance (left) and Florence Hendrickson as young schoolteachers in Savannah, Georgia, just after the turn of the century (Courtesy Harriet P. Stone.)

The Silas A. Peeler family included, from left to right, (sitting) Constance Peeler, Constance H. Peeler, and Harriet Peeler; (standing) Abraham Peeler, Silas A. Peeler, and Francis Peeler. Silas A. Peeler graduated from Clark University in Atlanta in 1893 and earned a B.D. from Gammon Theological Seminary in 1895. He married Constance Hendrickson, an 1892 Clark University graduate and a teacher in the public schools of Savannah. He was president of Bennett College from 1905 to 1913 (Courtesy of Harriet P. Stone.)

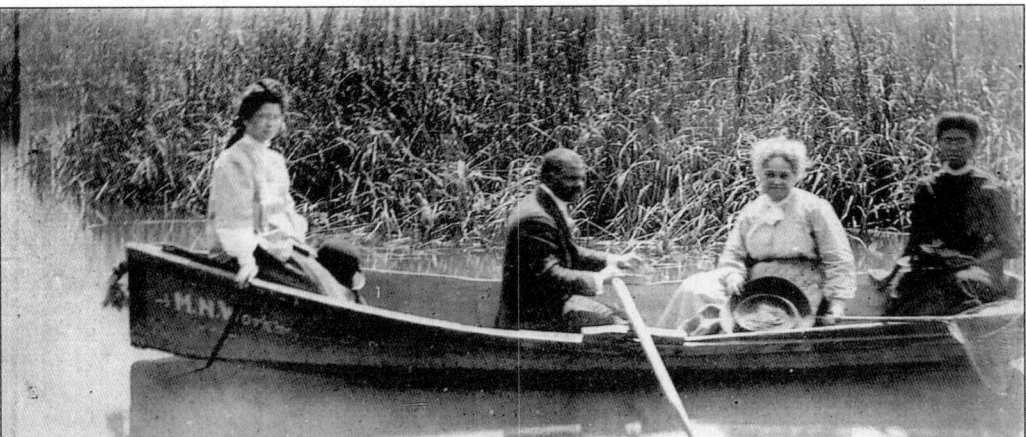

Monroe Nathan Work is rowing a boat near Georgia State Industrial College (GSIC) with his wife Florence (behind him), Harriet Hendrickson (in front of him), and other unidentified women in the bow of the boat. In 1904, Work married Florence E. Hendrickson, a Savannah schoolteacher. In 1903, he came to work under Richard R. Wright Sr. at GSIC. Work left GSIC in 1908 and went to Tuskegee, Alabama, to work with Booker T. Washington. (Courtesy of Harriet P. Stone.)

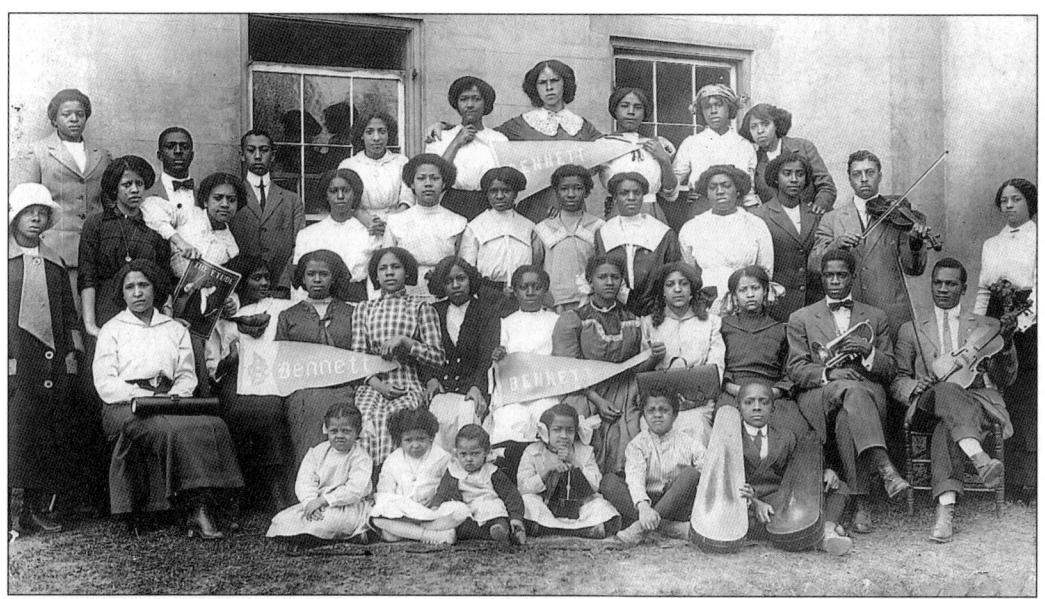

A music class is pictured at Bennett College in 1912. From left to right, sitting on the first row, are Constance Peeler, Ethel McNeil, Harriet Peeler, Mable Bullock, and Abraham Peeler. On the third row, the third person from the left is Cosette Peeler (sister of Harriet Peeler). On the fourth row, the third person from left is Wilbur Peeler (brother of the Peeler sisters). Anna Bullock (in white blouse and dark skirt) is the last person at the extreme right on the first row; she was the music teacher for the class. (Courtesy of Harriet P. Stone.)

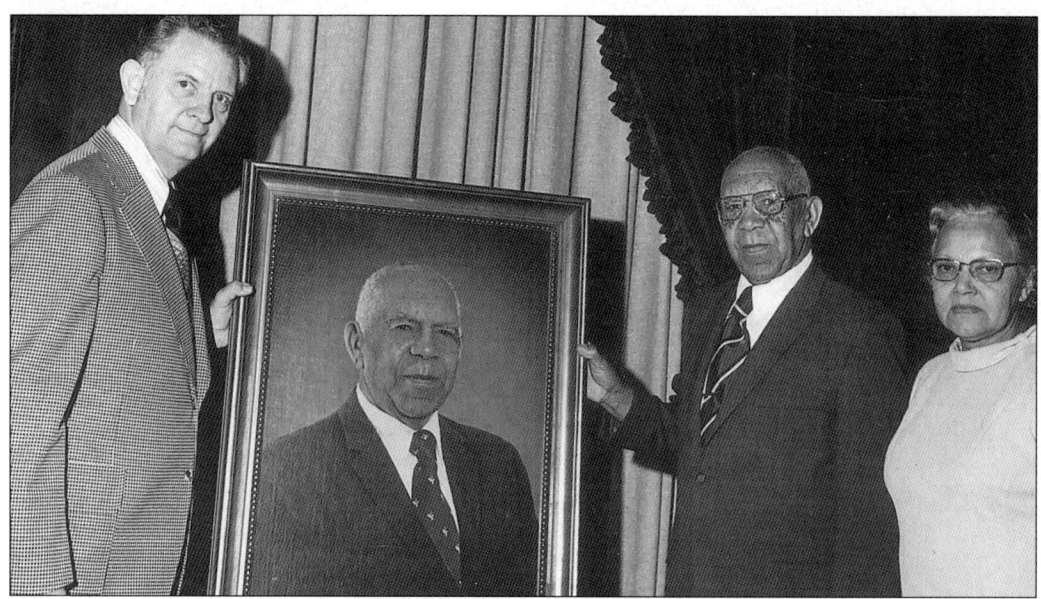

In 1973, Percy Stone's portrait was hung at the Rock Eagle 4-H Camp in Georgia as his wife observes. Stone married Harriet Peeler in 1938, received his B.S. degree from the University of Connecticut, and worked in the State Extension office at Georgia State College for over 25 years. Mrs. Stone, a graduate of Hampton Institute, received a master's degree from Howard University and taught at Georgia State College (Courtesy of Harriet P. Stone.)

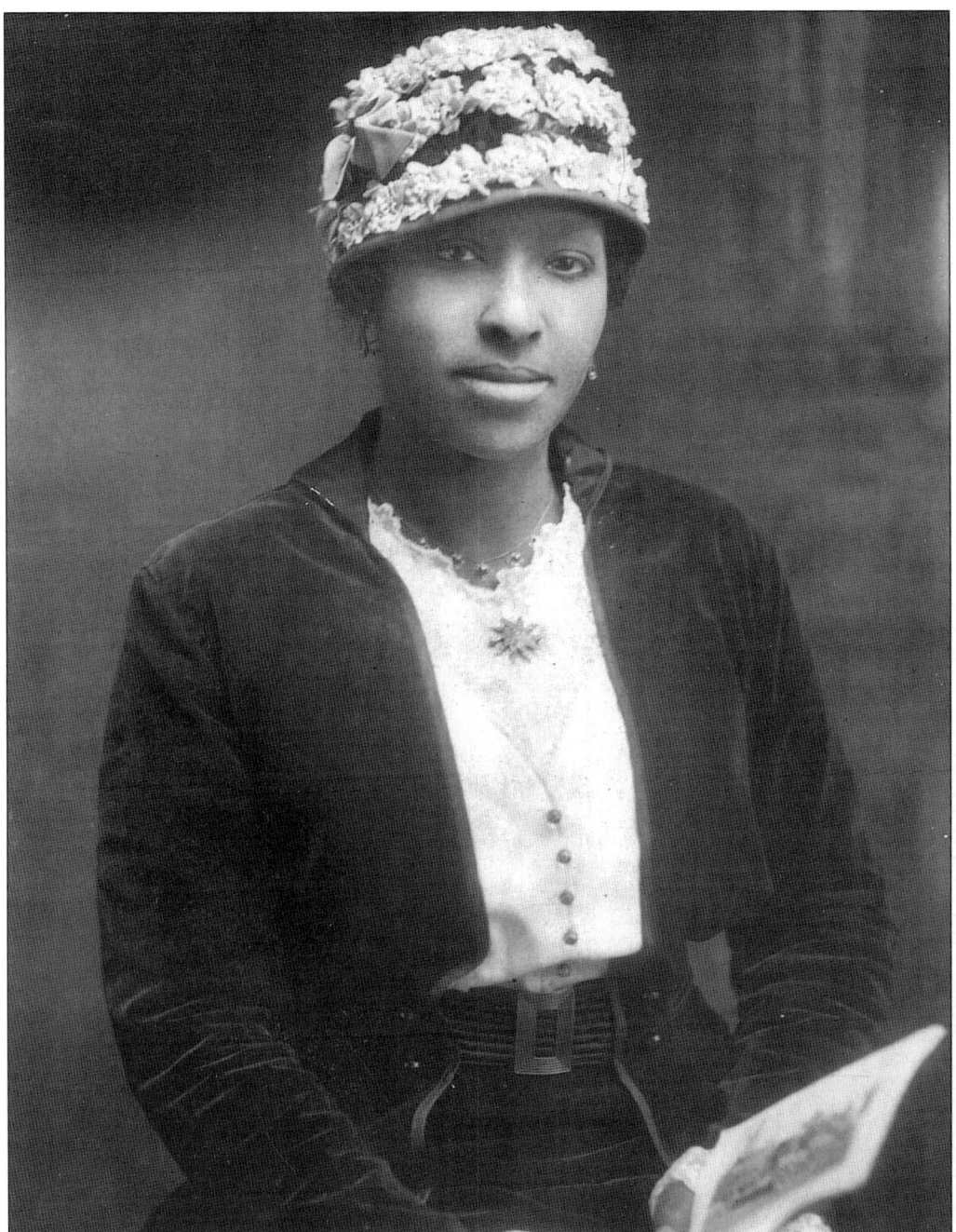

Mamie McGruder Pringle married Duncan Pringle and was a graduate of Atlanta University, where she was a classmate of James Weldon Johnson and Robert W. Gadsden in the 1890s. She wrote for the *Independent* newspaper in Atlanta, published by Benjamin Davis, was a pioneer black social worker in Savannah, and mentored Gertrude Green. The Pringles were the grandparents of Louise Lautier Owens. (Courtesy of Louise Lautier Owens.)

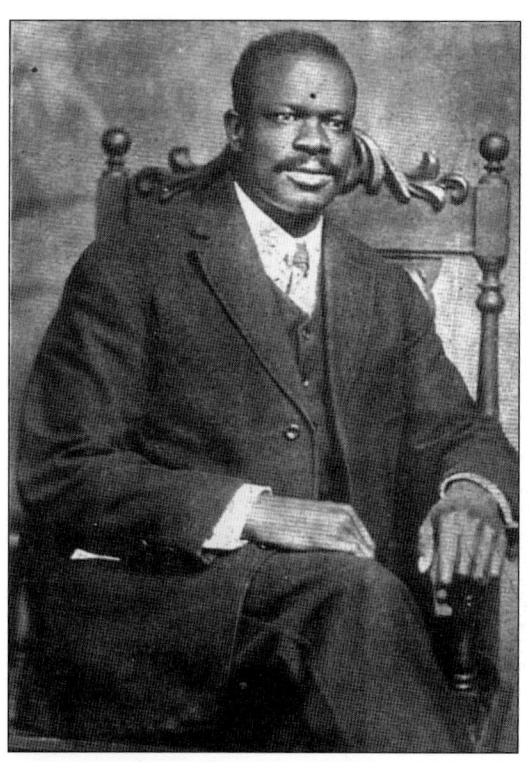

Duncan Pringle was born in Kershaw County, South Carolina in 1872, and came to Savannah in 1895. He was one of the organizers of the Chatham Mutual Insurance Company in 1916. He was a Mason and a prominent figure in the Grand Lodge. (Courtesy of Louise Lautier Owens.)

Duncan Pringle (seated, fifth from the left) was a stalwart in the Grand Lodge, Prince Hall Masons. This photograph is of the April 30, 1950 district meeting of the Masons in Savannah at the old Masonic Temple on West Gwinnett Street. (Courtesy of Louise Lautier Owens.)

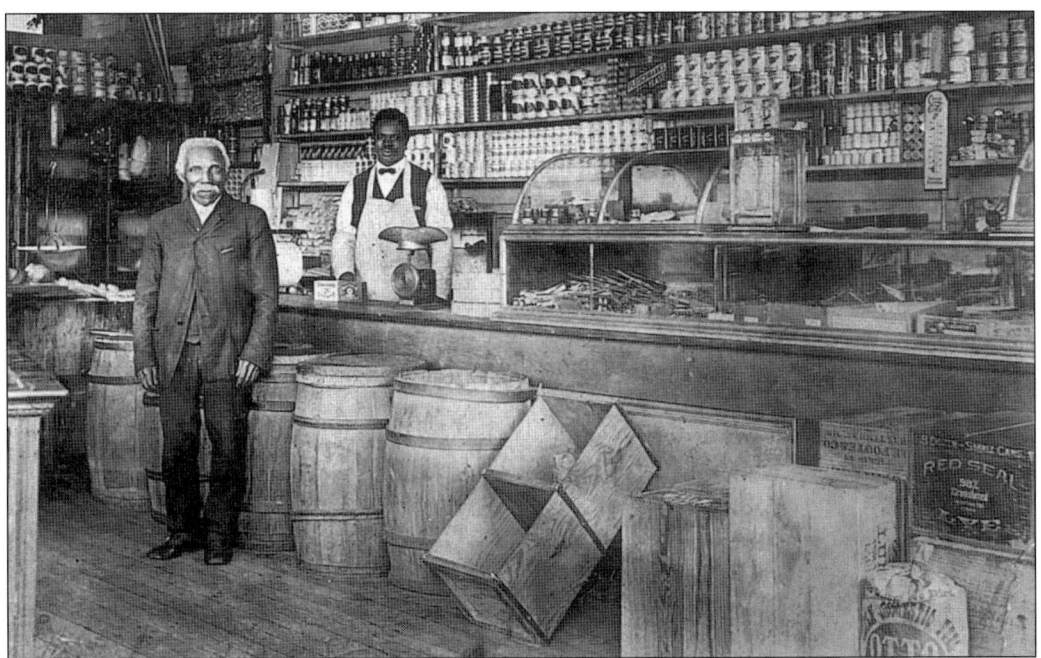
Duncan Pringle is standing behind the counter in his grocery store at the corner of East Broad and Henry Streets in 1908. A customer stands in front of the counter. (Courtesy of Louise Lautier Owens.)

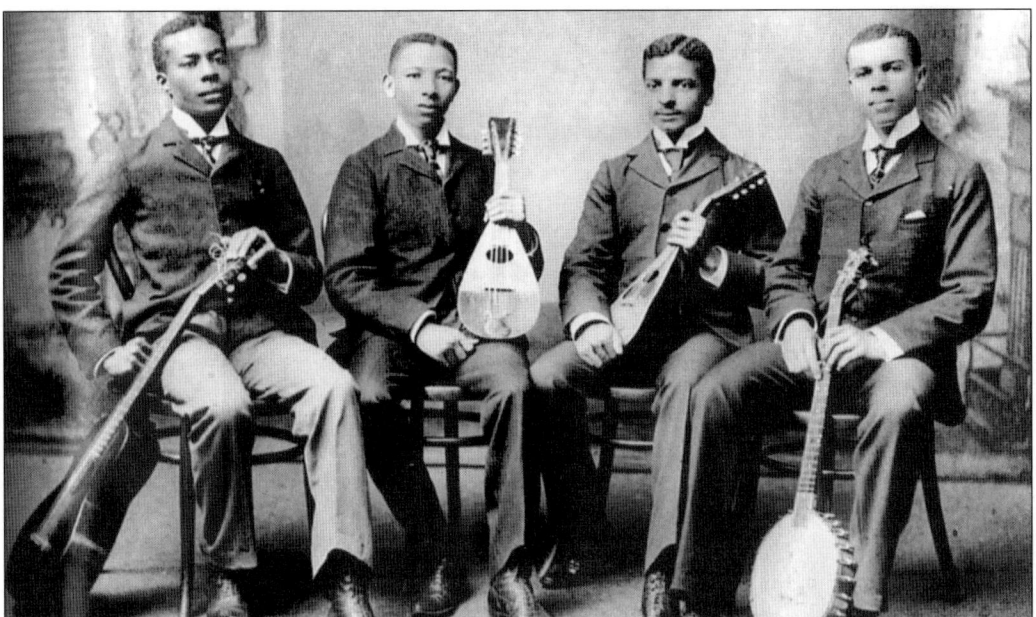
Robert W. Gadsden toured many northern cities with the famous Atlanta University Quartet to raise funds for the school. C.W. Motes took this 1894 photograph of the quartet. The musicians are, from left to right, Robert W. Gadsden, Joseph T. Porter, George A. Towns, and James Weldon Johnson. In 1896, Gadsden played fullback in the football contest between Atlanta University and Tuskegee Institute. (Courtesy of Georgia Department of History and Archives.)

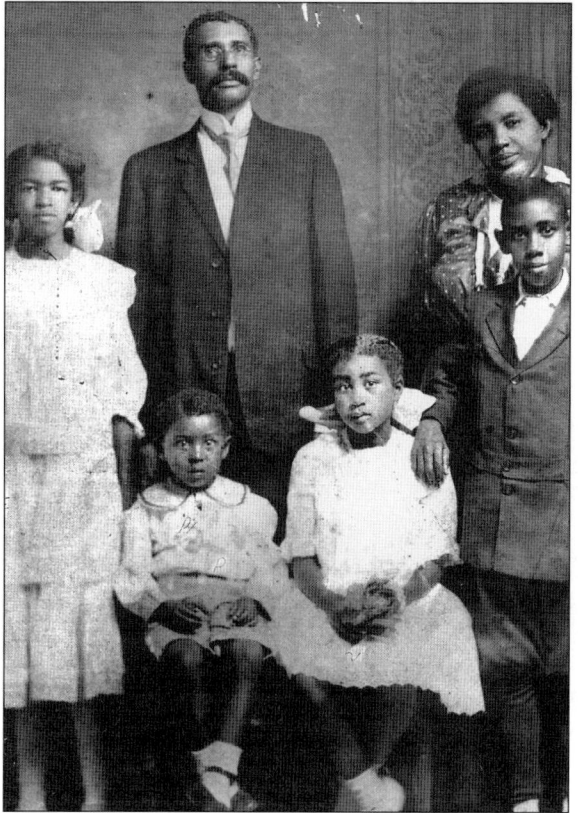

T.J. Hopkins presents a gift to Robert W. Gadsden for his years of service to the Savannah Library Board. Looking on are Sidney A. Jones (left), pioneer funeral director, and John A. Singleton. Gadsden was an organizer of the Carnegie Library on February 26, 1906. He came to Savannah to teach in 1902, and from 1904 until his retirement in 1947 he was the principal of Paulsen and East Broad Street Schools. (Courtesy of Lucy Gadsden Solomon.)

The family of Rev. Samuel Tyler Redd are pictured c. 1918. Standing from left to right are Eliza Redd Grigsby, Samuel Tyler Redd Sr., Mattie Kent Redd, and Samuel Tyler Redd Jr.; Seated are Aspinwall "Pat" Redd and Charlotte Veronica Redd Douglass. Reverend Redd came to Savannah in 1904 as pastor of Ezra Presbyterian Church. Under his leadership the church was named Butler Presbyterian Church after Robert M. Butler, a wealthy white benefactor to the church. (Courtesy of Orion L. Douglass.)

Charlotte Veronica Douglass graduated from Talladega College in 1929 and married Otha L. Douglass Sr. She was a master teacher and taught for over 36 years in Savannah at West Broad, Anderson, and Henry Street Schools. The Douglasses were the parents of Olinda, Orion, and Otha Jr. (Courtesy of Orion L. Douglass.)

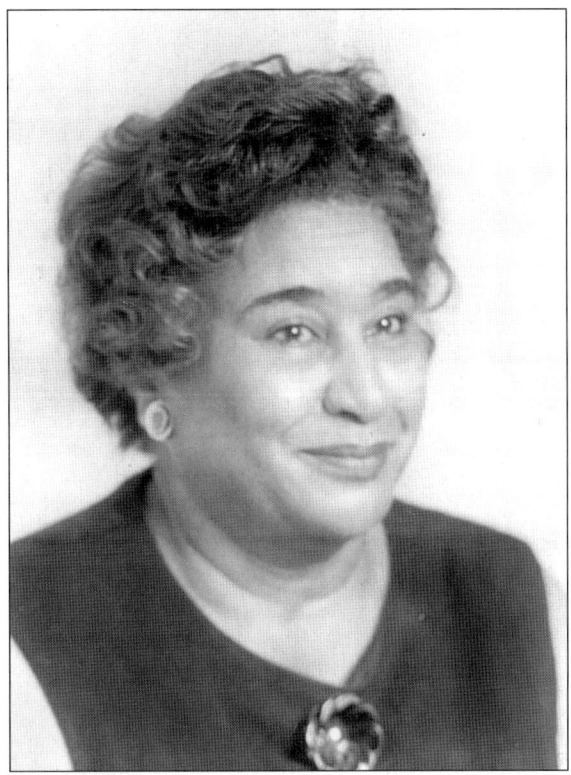

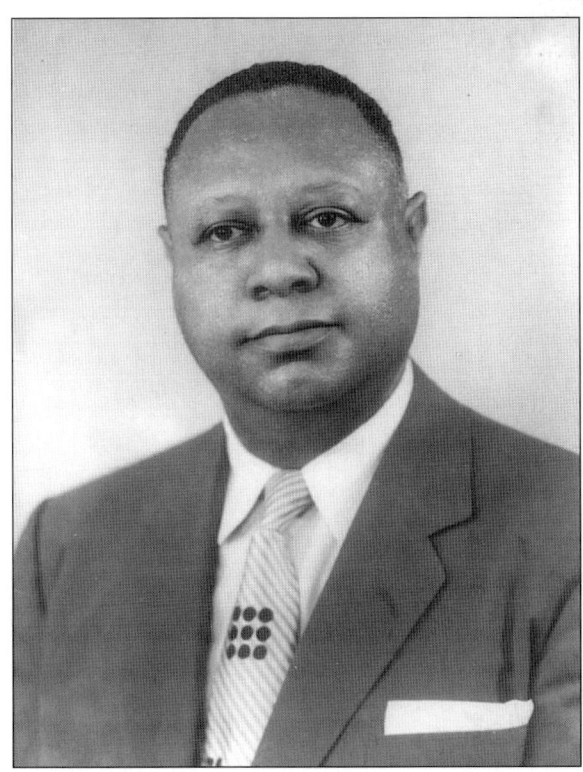

Otha L. Douglass Sr. came to Savannah in 1938 and served as principal of Beach-Cuyler High School in the late 1940s. He was the first principal of the new Alfred E. Beach High School in 1950, where he remained for 15 years. Douglass was a graduate of Morehouse College and received an M.A. degree from Atlanta University (Courtesy of Orion L. Douglass.)

17

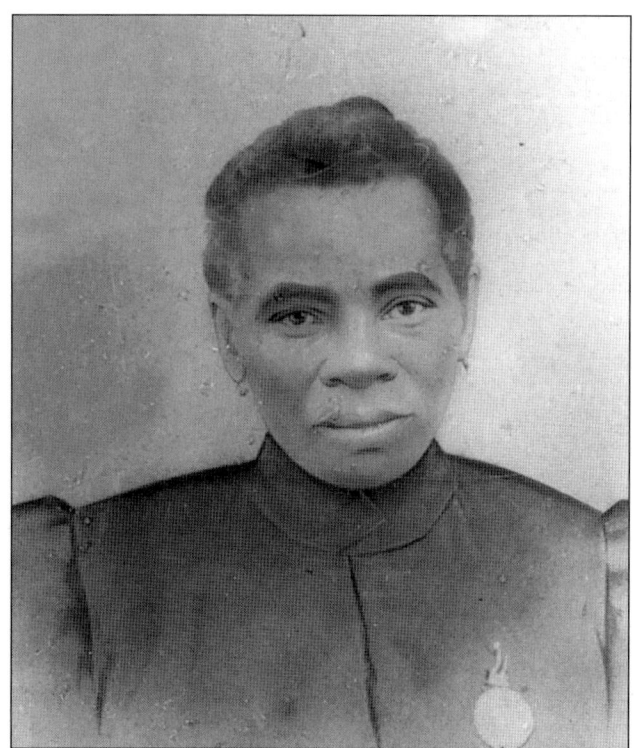

Lucy Anna Powell Steele was born a slave in Harris Neck, Georgia, on October 27, 1852. She was the daughter of Mr. and Mrs. Honor Powell of McIntosh County, Georgia. She was the sister of Mrs. James (Patsy) Landorf and George Powell. Lucy Anna Powell married Louis Steele on September 1, 1869, and was the mother of seven children. (Courtesy of Charles J. Elmore.)

Louis Steele was born as a slave in Savannah in the 1840s. He was the son of Alexander Steele—a nominal slave, who sold horses for a living—and Daphne Steele. Louis had five siblings: Joseph, Charles, Pender, Kate, and Roderick Steele. He and Lucy Powell Steele were the parents of Paul Joseph Steele, Mamie Steele Cox, Lucy Steele Gaston, Chloe Steele Williams, Viola Steele Clouden, James Steele, and John Steele. (Courtesy of Kana Mutawassim.)

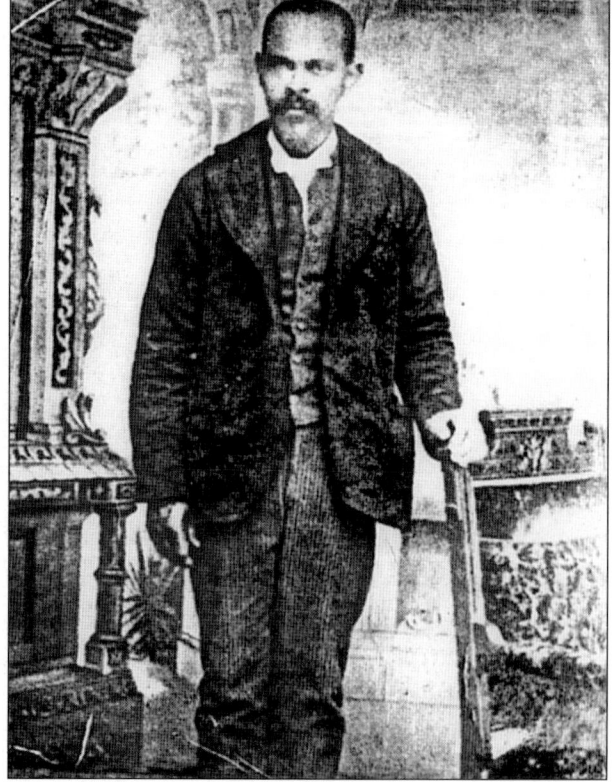

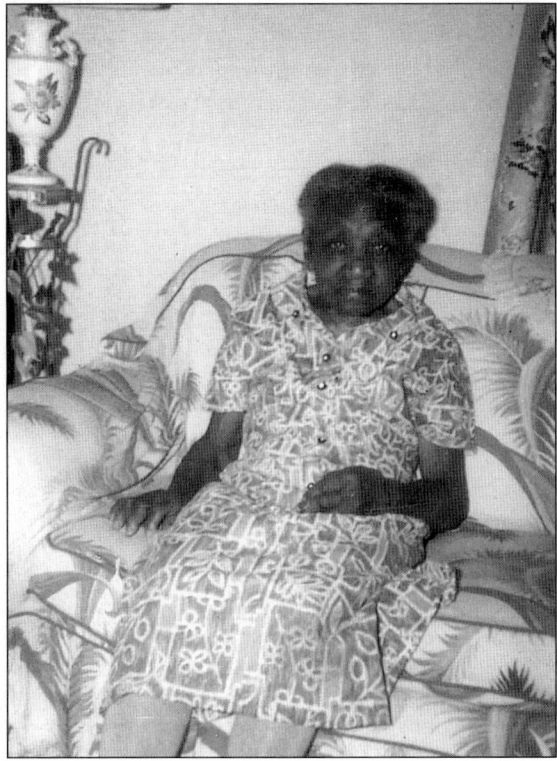

This is a facsimile of the original normal diploma of Hattie O. Wilson Steele, which she received from Clark University in Atlanta on May 17, 1894. (Courtesy of Roderick Steele Family.)

Hattie O. Wilson Steele was born April 22, 1872. She attended Haven Home School in Savannah, was an 1894 graduate of Clark University in Atlanta, and taught nine years in a one-room schoolhouse before her marriage to Roderick Steele in 1922. She received her initial teaching certificate on June 10, 1890 to teach third grade. She was the mother of Isaac, Willie, Esther, Clifford, Everett, Rebecca, and Herman. Hattie O. Steele died in 1981. (Courtesy of Roderick Steele Family.)

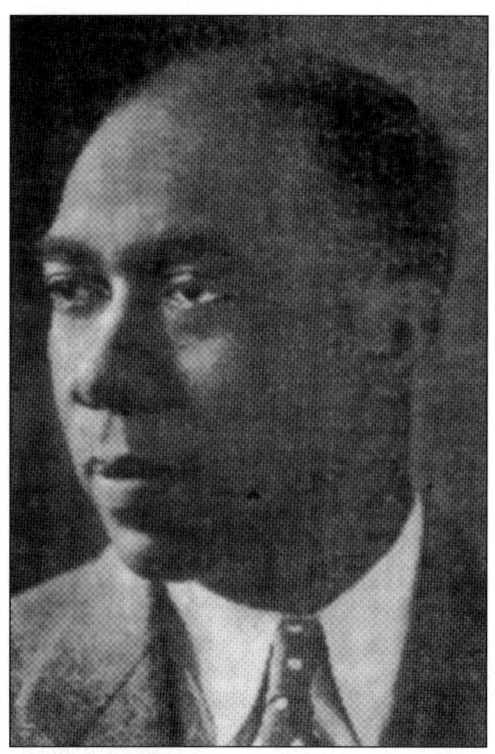

Frank Callen was born in Savannah in 1886, and graduated from Georgia State Industrial High School Department in 1907. He founded the Savannah Boys Club in 1917 in the old McDonald house on Charlton and Price Streets. Mrs. Henry W. Hodge assumed the mortgage on the building, which was $11,000. He served the Juvenile Court of Chatham County as a probation officer for over 25 years and was married to Erma Curley Callen. (Courtesy Agatha Curley Morris.)

Charlotte Curley, wife of Frank Curley Sr., a well-known civic worker in Savannah, was director of the Mills Home for Senior Citizens, and instrumental in fund-raising and the erection of a new Charity Hospital for African Americans in 1929–1930. Through her efforts and others, white and black Savannahians raised $60,000 to erect the hospital. The Curleys were the parents of Rebecca, Erma, Amanda, Agatha, Rosemary, and Frank Jr. (Courtesy of Agatha Curley Morris.)

Erma Curley Callen married Frank Callen in the early 1920s. She was the daughter of Frank Curley Sr. and Charlotte Curley. She taught elementary school at Florence Street School in the 1930s when Emma Quinney was principal. After Frank Callen died in 1949, she continued to direct the Frank Callen Boys Club until the early 1960s. (Courtesy of Agatha Curley Morris.)

Agatha Curley Cade was the wife of Mike Cade. She taught for over 30 years at the East Broad Elementary School as well as Florence Elementary School. (Courtesy of Agatha Curley Morris.)

Rosemary Curley Brooks taught school in Savannah and was a pioneering teacher supervisor. She left Savannah and continued a long teaching career in Jacksonville, Florida. (Courtesy of Agatha Curley Morris.)

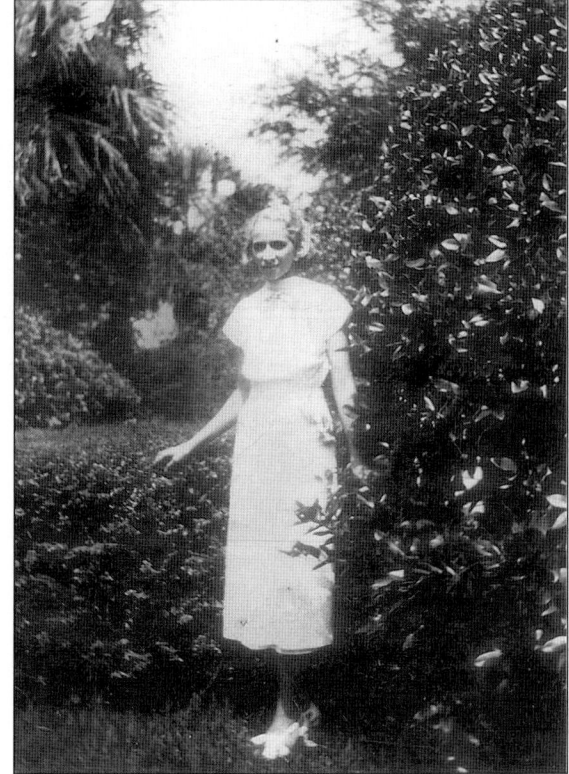

Agatha Curley, pictured on the left, served as matron of honor at her aunt Rebecca Curley's wedding to Ormonde E. Lewis Sr. Mrs. Rebecca Lewis served for many years as a social worker in Savannah's Department of Public Welfare. She was also a graduate of Georgia State Industrial College High School Department. (Courtesy of Agatha Curley Morris.)

(left) Rebecca Stiles Taylor organized and was the first president of the Savannah chapter of the National Association of Colored Women in 1918. She joined Mary McLeod Bethune in 1919 to organize the Southeastern Region National Association of Colored Women, serving as corresponding secretary and president of the Georgia State Federation. From 1923 to 1927 she was president of the Southeastern Region, succeeding Mary McLeod Bethune. (Courtesy of John R. Stiles Jr.)

(right) These are the children of John and Lucille Stiles. John was a mail carrier and a graduate of Hampton Institute. From left to right are (front row) Geraldine and Samuel; (back row) Lucille, John Jr., and Ann. Ann Stiles married John Falconer and was a missionary in Monrovia, Liberia, West Africa, for 37 years, and erected a hospital there. (Courtesy of John R. Stiles Jr.)

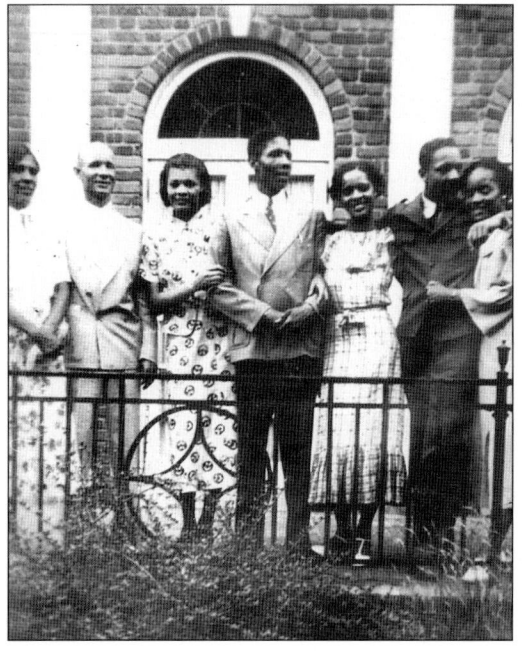

John R. Stiles Jr. is pictured after his graduation from Hampton Institute in 1937. Seen from left to right are Lucille Stiles (mother), John R. Stiles Sr. (father), Ann Stiles, John R. Stiles Jr., Lucille Stiles, Samuel Stiles, and Geraldine Stiles. (Courtesy of John R. Stiles Jr.)

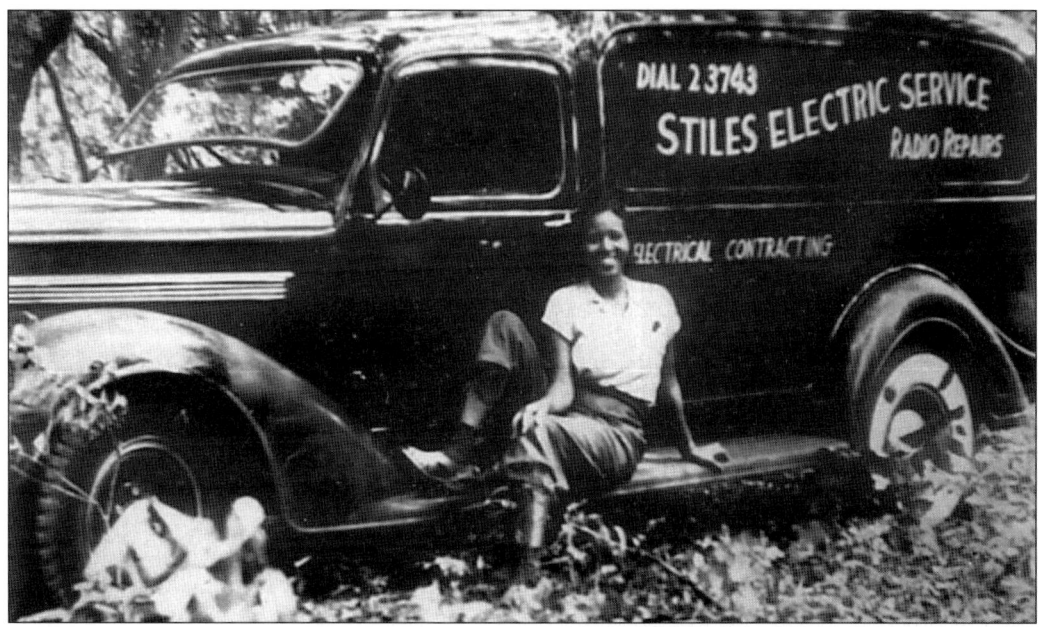

Thelma Williamson Stiles, wife of John R. Stiles Jr., sits on the sideboard of his Stiles Electric Services business truck in 1941. John R. Stiles Jr. was the second black certified-bonded electrical contractor in Savannah. He married Thelma Williamson, a Hampton Institute (B.S.) and Atlanta University graduate (M.A.) in 1940. She taught in the public schools of Savannah, and was one of the first blacks to teach in an integrated setting in Savannah (Courtesy of John R. Stiles Jr.)

This is a facsimile of the March 30, 1932 application of Asbury Methodist Episcopal to the Boy Scouts of America for a new troop charter for African-American boys. Samuel L. White Sr. served as Scoutmaster of Troop 47. Troop 45 was established at St. Stephens Episcopal (now St. Matthews) where Father Gustave Caution was pastor; Troop 46 was established at First Congregational and James King was Scoutmaster; Troop 48 was established at First African Baptist with John Delaware as Scoutmaster. (Courtesy of James Cobham.)

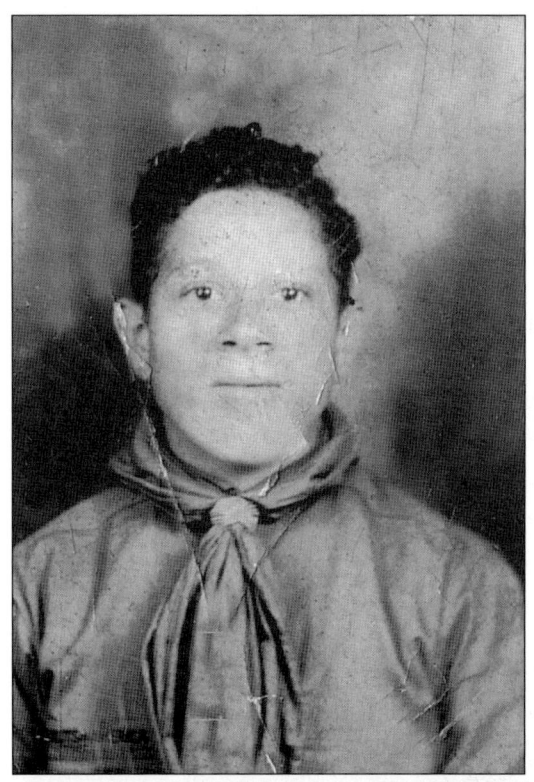

James Cobham is seen in 1933 as a member of Troop 47. The other members were Herman Brown, Leonard Burnette, Robert Brooks, Frank Chatman, J.T. Daniel, Groover Eubanks, Fred Handy, Edward Jackson, Earl McDonald, Marion Pryor, John Pryor, Leviticus Baker, Willis Hubert, Frank Blackshear, Joe Butler, Frank Coles, Henry Eason, Herbert George, Alphonso Gilmore, Joseph Hall, William Jones, Charlie Kiett, Coleman Rhodes, William Seabrooks, Charlie Sexton, Frazier Spahn, William Spahn, and Wilkin Waters. (Courtesy James Cobham.)

James Cobham (extreme left, second row) is pictured with members of Troop 255 of Butler Presbyterian, his last troop. He retired from scouting in 1976 after 37 years as a scoutmaster and more than 50 years in scouting. He retired from the U.S. Postal Service after a lengthy career. Cobham involved his five sons in scouting (they were all in his troop) and his two daughters in the Girl Scouts of America.

Two
THE CIVIL WAR

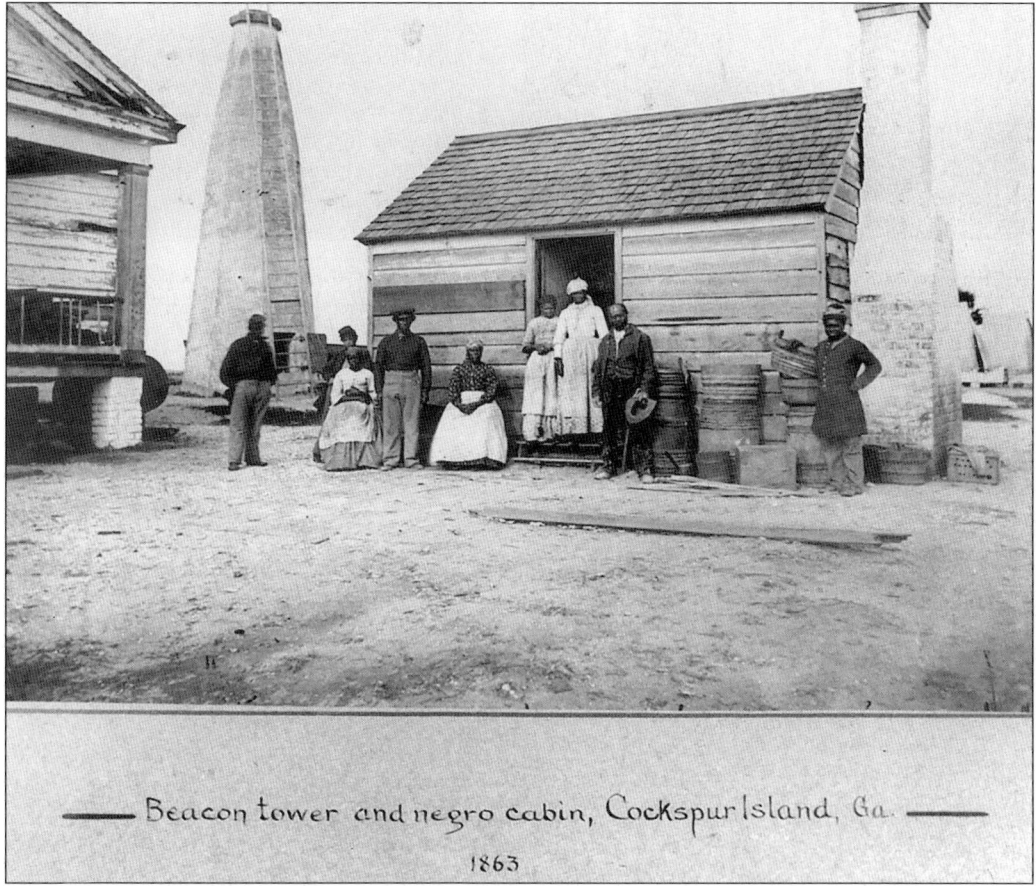

The Beacon tower and Negro cabin are seen at Cockspur Island, Georgia, near Fort Pulaski (1863). These slaves became free when Gen. David Hunter captured Fort Pulaski from the Confederacy in April 1862. Many of these people worked as carpenters, seamen, general laborers, cooks, and Union soldiers. (Courtesy of John Breen, Fort Pulaski National Monument.)

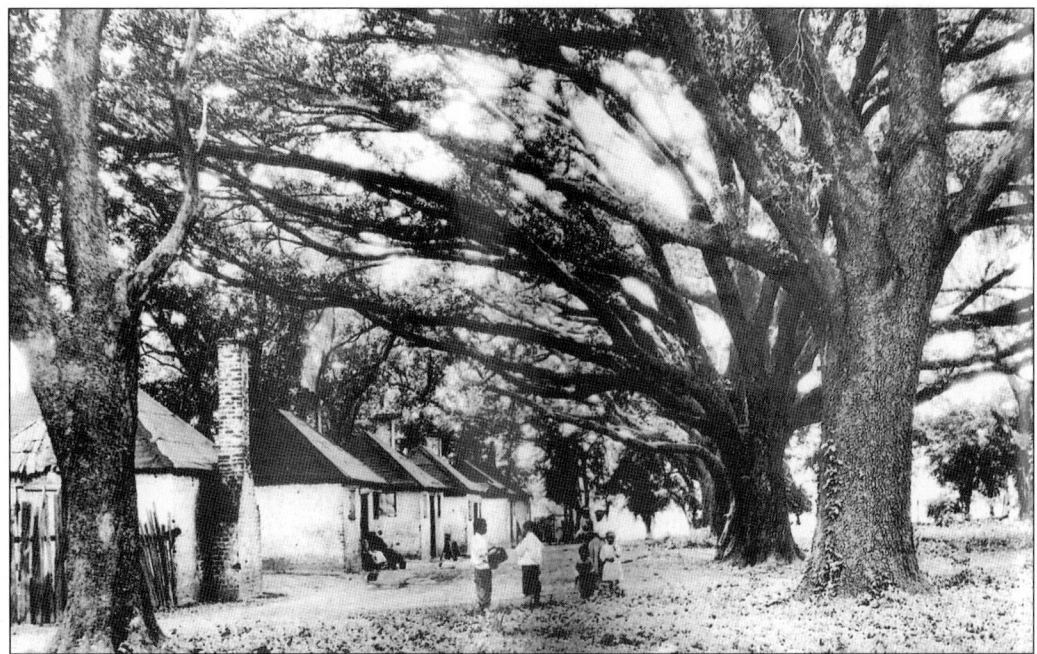

Black families lived in former slave cabins on the Hermitage Plantation, *c.* 1900. The Hermitage Plantation was the estate of the McAlpin family from 1819. They built a mansion there in 1830. The plantation was originally settled in 1783, and consisted of 500 acres along the Savannah River. It was representative of the typical ante-bellum plantation in the South. (Courtesy of Georgia Department of History and Archives.)

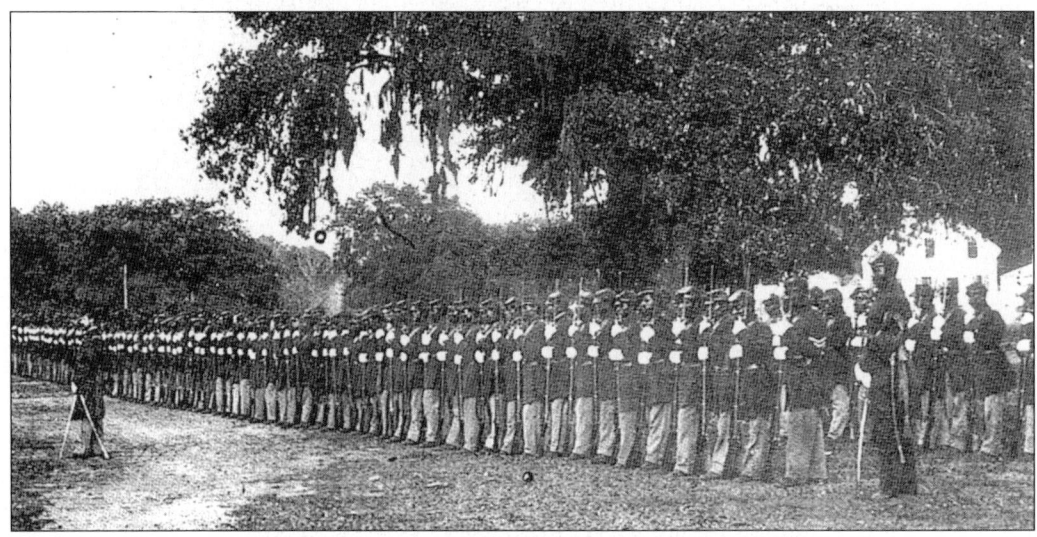

The First South Carolina Volunteers are at parade rest hearing the reading of the Emancipation Proclamation in 1863. Gen. David Hunter organized the First South Carolina Volunteers in 1862 without the sanction of President Lincoln. In 1863, the government officially sanctioned the United States Colored Troops. Samuel Gordon Morse, an African-American Savannahian, joined the Union Army in Savannah on January 1, 1863, on Emancipation Proclamation Day. (Courtesy of John Breen, Fort Pulaski National Monument.)

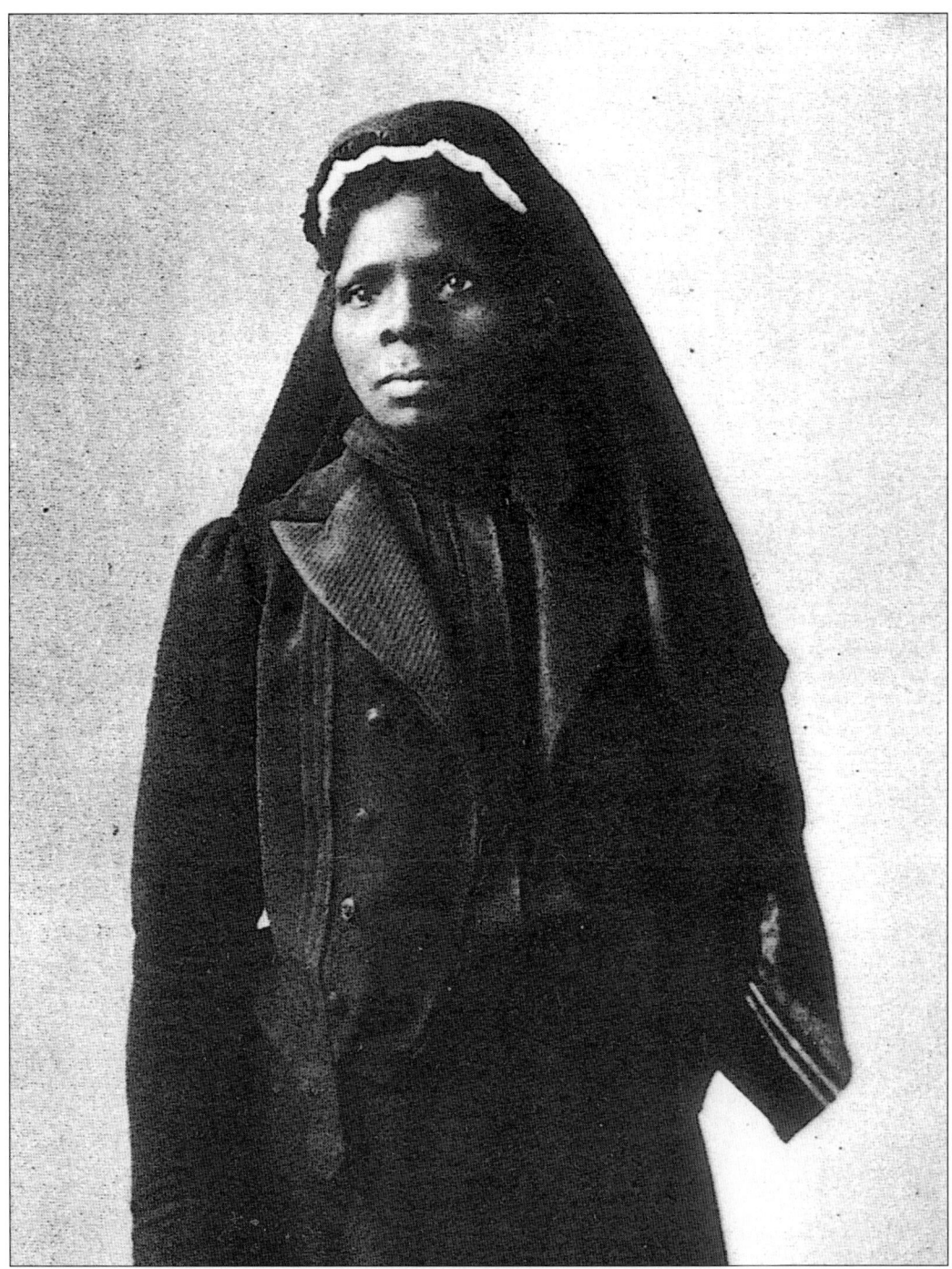
Susie King Taylor was raised in Savannah and was secretly taught to read and write by Mary Woodhouse, a free black. She married Edward King in 1862 and he joined the First South Carolina Volunteers at Port Royal. She worked with Clara Barton in Beaufort, South Carolina, teaching black soldiers. She opened a school in Savannah after the Civil War, and settled in Boston in 1872.

This meeting in Savannah took place on January 12, 1865. Pictured from left to right are General Sherman, Edwin Stanton, U.L. Houston, W.J. Campbell, John Cox, and James Lynch. Standing is Garrison Frazier, black spokesman; to the right is a Union officer taking minutes; James Porter is next to him. W.J. Gaines and Alexander Harris are also present. On January 16, 1865, Sherman issued Field Order No. 15, in Savannah, known as "Forty Acres and a Mule." (Courtesy of The Marshall House, Kurt Ratzlaff, general manager.)

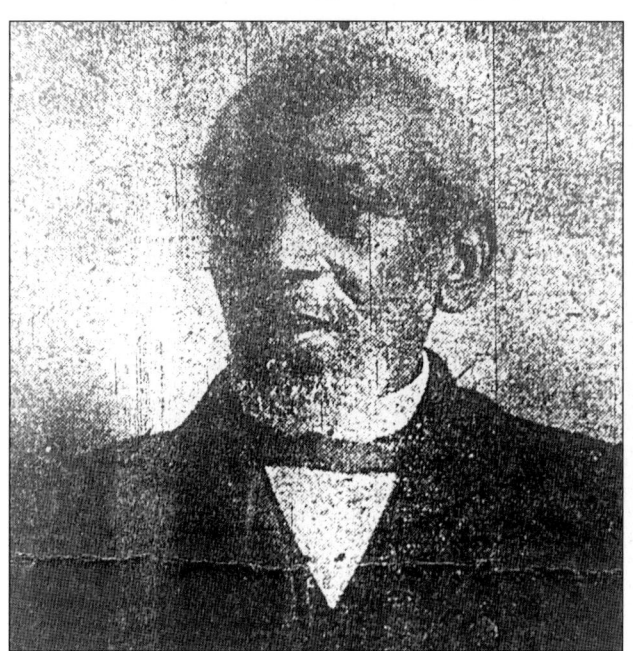

Alexander Harris was a deacon, trustee, and interim pastor of First Bryan Baptist Church. He was conscripted into the Confederate army and served in the Republican Blues during the Civil War, and has the Southern Cross of the Confederacy at his Laurel Grove South gravesite. He was with Garrison Frazier and 19 other black ministers who met with General Sherman at the Green-Meldrim Mansion on January 12, 1865. (Courtesy of *Savannah Tribune*.)

John H. DeVeaux was the first black collector of customs at the Port of Savannah (1898) and Brunswick (1889), and was a lieutenant colonel in the Georgia State Colored Troops. During the Civil War he was a mess boy with the *Mosquito Fleet* of the Confederacy in the Savannah area. He was one of the organizers, with James M. Simms, of the Grand Lodge of Georgia (1870), and served as grand master for 12 years. He founded the *Savannah Tribune*, a weekly black newspaper in 1875. (Courtesy of *Savannah Tribune.*)

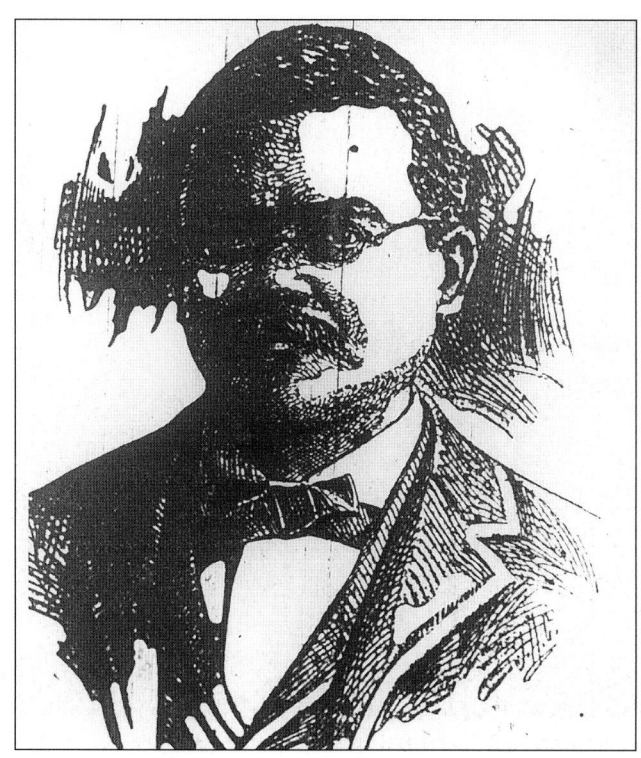

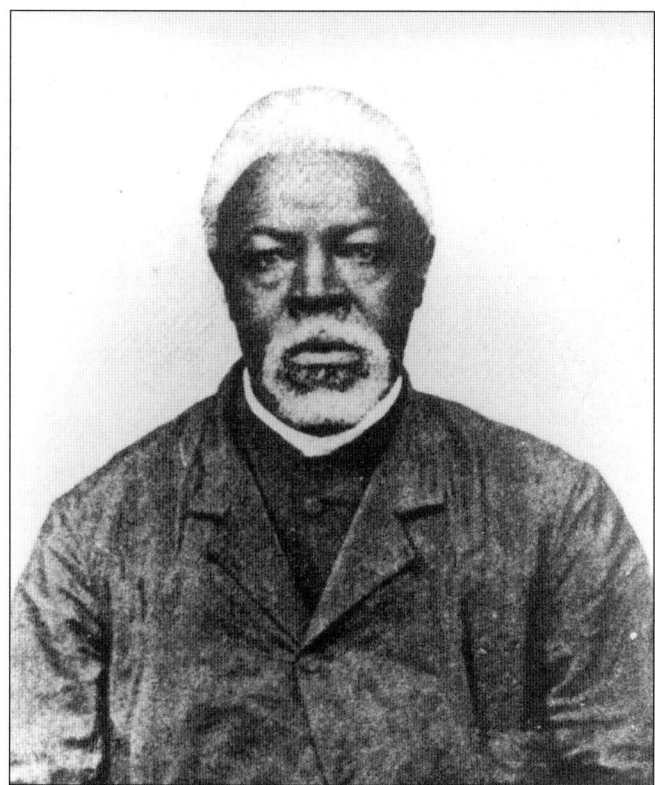

Ulysses L. Houston was the first member of Third African Baptist Church (now First Bryan Baptist Church) to become its pastor; he served from 1861 to 1889. Houston also served in the Georgia Legislature during Reconstruction (1869–1871). Along with John DeVeaux, James M. Simms, Alexander Harris, Charles DeLamotta, Louis B. Toomer and others, Houston was a charter member (1866) of Eureka Lodge #1 A.F. and A.M. He was with Garrison Frazier at the meeting with General Sherman at the Green-Meldrim Mansion. (Courtesy of First Bryan Baptist Church.)

James Merilus Simms was a Union Army chaplain during the Civil War. During Reconstruction, he represented Chatham County in the Georgia Legislature. On February 4, 1866, he organized Eureka Lodge #1, the first black Masonic lodge in Georgia. He also organized the Grand Lodge of Georgia in 1870 and became the first black Masonic Grand Master in Georgia's history. He wrote the history of First Bryan Baptist Church in 1888. (Courtesy of First Bryan Baptist Church.)

Three
RELIGION

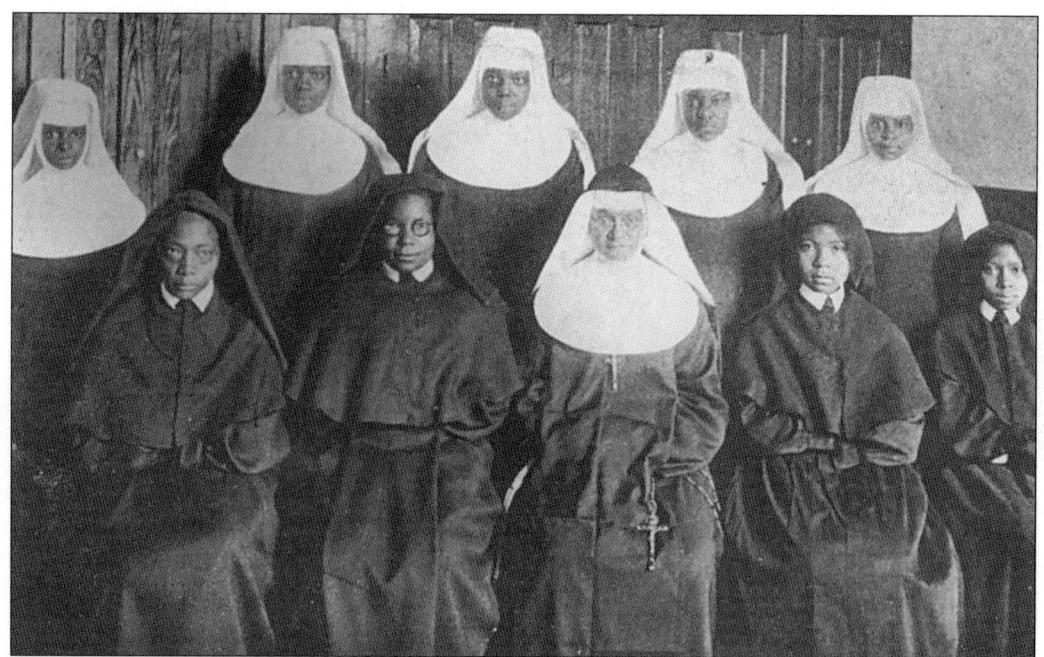

These are the first members of the Franciscan Handmaids of the Most Pure Heart of Mary (1917). Mother Mary Theodore Williams (first row, third from the left) was the First Superior General of the order. On March 12, 1917, Bishop Keily, Diocese of Savannah, approved the formation of the black nuns. (Courtesy of Pauline E. Elmore.)

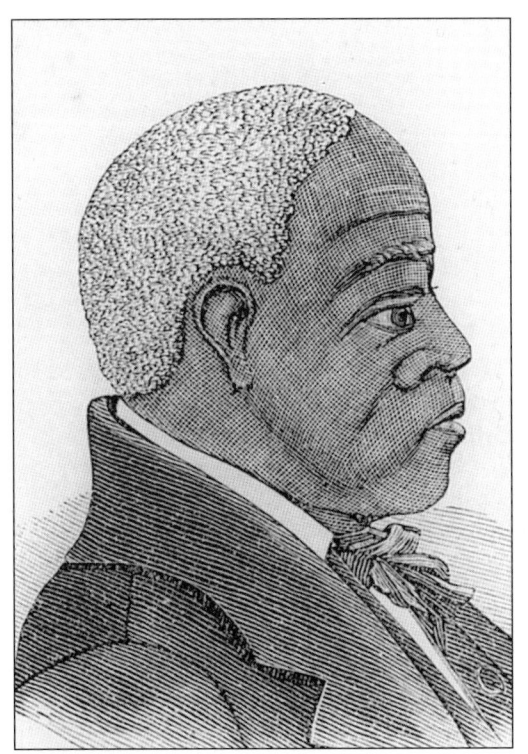

Andrew Bryan was baptized by George Liele, a black preacher, in 1782. He was ordained a minister January 19, 1788, by Abraham Marshall, a white minister, and Jessie Peters, a slave minister. On January 20, 1788, Marshall and Peters baptized 45 of Bryan's followers, and named Bryan minister, at Brampton Plantation. The new church was called First Colored Baptist Church. From this church evolved First African and First Bryan Baptist Churches. (Courtesy of First Bryan Church.)

First Bryan Baptist Church was established by Andrew Bryan in 1788. It became known as Third African Baptist after an 1832 doctrinal split with First African Baptist Church. Today, the church remains on the property bought for First Colored Baptist by Andrew Bryan in 1793. It is the oldest piece of continuously owned church property by a black congregation in America. The current church was dedicated in 1873. (Courtesy of John Cochran.)

Andrew Cox Marshall was baptized by Andrew Bryan, his uncle. He was born a slave in 1755 and lived to be 100 years old. He was pastor of First African Baptist Church from 1817 until the split of 1832 with Third African Baptist. In 1832, First African Baptist moved to Franklin Square into the old wooden church of the white Savannah Baptist congregation after they erected a new church. Marshall died in Richmond, Virginia in 1856 while soliciting funds for the church. (Courtesy of *History of First African Baptist.*)

First African Baptist Church was built by slaves, who hired out their time after working on plantations to pay for the new church. The current church was built in 1859, at which time James Merilus Simms was the church clerk and the carpenter on the construction crew that built the church. In 1859, William J. Campbell was pastor, and he met with Sherman and other black ministers at Green-Meldrim Mansion in January of 1865. (Courtesy of John Cochran.)

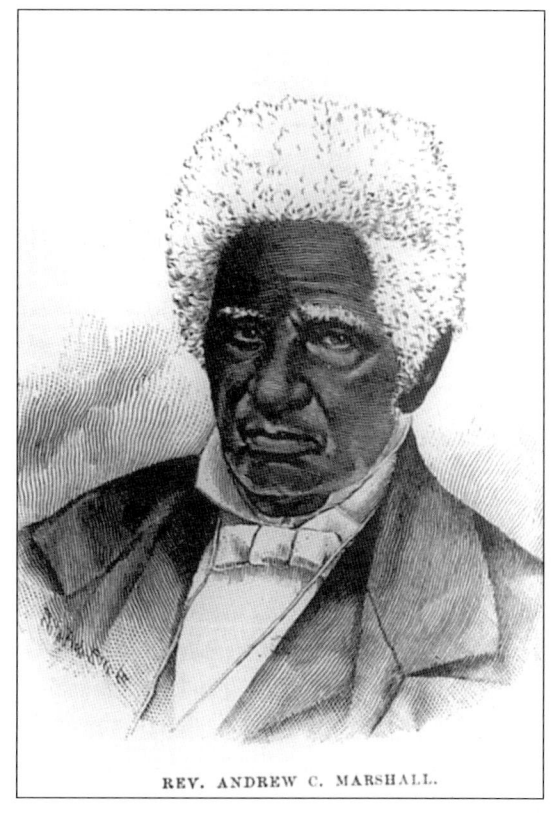

REV. ANDREW C. MARSHALL.

35

Emanuel King Love was born in 1850, graduated from Augusta Baptist College (now Morehouse College), and became pastor of First African Baptist Church on October 1, 1885, at age 35. In 1891, he and other Savannah blacks were instrumental in establishing Georgia State Industrial College, now Savannah State University. He was a personal friend of Richard R. Wright Sr., and wrote the history of the church in 1888. (Courtesy of *History of First African Baptist*.)

Lula E. Hines was married to William H. Jackson June 23, 1893. Rev. Emanuel K. Love performed the service at First African Baptist Church. The newlywed couple eventually moved to Boston, Massachusetts, and raised a family. (Courtesy of Elizabeth Fenderson.)

Thomas J. Goodall was born in Tennessee in 1886, and became pastor of First African Baptist Church in 1915. He was a trustee of Central City College, moderator of the Mt. Olive Baptist Association, and a member of the Benefit Board of the National Baptist Convention. (Courtesy of *History of American Negro*, Georgia Edition, Volume II, 1920.)

J.J. Lewis was pastor of Asbury Methodist Church in 1933–1934. He was instrumental in retiring the church's debt during his tenure. (Courtesy of Asbury United Methodist Church.)

Proctor W. Wrenn became pastor of Second Baptist Church in 1917, and came to Savannah from Greenville, Mississippi. There he pastored Mt. Horeb Baptist Church for eight years and built a $20,000 brick church. (Courtesy of *History of American Negro*, Georgia Edition, Volume II, 1920.)

Nepton Bembry was born in 1865. In 1886 he was licensed to preach and joined the Conference at Dawson, Georgia, under Bishop W.J. Gaines in 1890. He came to Gaines Chapel in Savannah, and after three years, presided over the West Savannah District. He became pastor of St. Phillip Monumental (1920), mother church of the AME church in Georgia, founded June 16, 1865. (Courtesy of *History of American Negro*, Georgia Edition, Volume II, 1920.)

Allen L. Sampson was born in 1867 in Quitman, Georgia. Bishop Henry McNeal Turner ordained him an elder in 1905. He worked in 1902 as a blacksmith in Savannah. In 1917, he was appointed presiding elder of the West Savannah District to fill out the term of T.M.N. Smith. In 1920, he was appointed pastor of the St. James Station in Savannah. (Courtesy of *History of American Negro*, Georgia Edition, Volume II, 1920.)

D.W. Stephens became pastor of Bethel A.M.E. in 1926 when it was located at the corner of East Broad Street and Gwinnett. The church was located in the Sixth Episcopal District, Georgia Annual Conference, and was one of the oldest Methodist churches in Savannah. (Courtesy of *Yearbook Colored Savannah*, published by Georgia State Industrial College, 1933.)

Asbury United Methodist Church was founded in 1871 as a Methodist Episcopal chapel with Rev. C.O. Fisher as pastor. The first church was on Gwinnett and West Broad Streets, and was named after Bishop Francis Asbury. Under Rev. E.W. Rakestraw (1924–1927) the church moved to its present location on Abercorn Street. The church's roots stem from the Wesley and Andrew Chapel during the Civil War. (Courtesy of Asbury United Methodist Church.)

Robert F. Herrington served as pastor of Asbury United Methodist Church from 1936 to 1938, and was noted for faithful service to the church and retirement of the church's debt. (Courtesy of Asbury United Methodist Church.)

Marie Hardwick was born in Savannah and served as head matron in Miner Hall Dormitory at Howard University. The sister of Isabell Harris Smitherton and Harry Gordon, Marie was the matriarch of the Hardwick family. She was a stalwart of Asbury United Methodist Church and donated the church's organ. (Courtesy of Harriet P. Stone.)

P. Harold Gray (pictured with his wife) was the pastor of Asbury United Methodist Church from 1961 to 1969. Under his leadership, church membership increased by 103 members, he increased the church's property, installed a new choir stand, and purchased a new church organ. Reverend Gray became a United Methodist district superintendent. (Courtesy of Asbury United Methodist Church.)

Bingley S. Hannah was born in 1866, and came to Savannah from Brunswick Station A.M.E. to Bethel Station A.M.E., Savannah (c. 1914) where he built a parsonage. He was then promoted to the district, and presided over the Savannah District A.M.E. for five years. He was a trustee of Morris Brown College and Central Park Normal in Savannah. (Courtesy of *History of American Negro*, Georgia Edition Volume II, 1920.)

Charles C. Cargile was born in 1858 and attended Storrs School and Atlanta University. He preached at St. Philips Station in Savannah for three years. In 1920, he headed the Savannah District, and his headquarters were located at 921 40th Street (Courtesy of *History of American Negro*, Georgia Edition Volume II, 1920.)

Richard H. Singleton was born in 1865 and graduated from Giles Academy in 1888. In December 1899, he was sent to St. Philip Monumental, Savannah, to rebuild the church after the storm of 1896. He remained there until 1901 and rebuilt the church. Bishop C.S. Smith appointed him Presiding Elder of West Savannah District. After one year, he was appointed pastor in 1909 of St. Philip A.M.E. Church at West Broad and Charles Streets. A new church was built in 1912. (Courtesy of *History of American Negro*, Georgia Edition, Volume II, 1920.)

St. Philip A.M.E. Church was established in 1896 when members split from the St. Philip Monumental A.M.E. Church on New Street after a storm destroyed the church. The members bought the Epworth M.E. South Church from a white congregation, and worshiped there until a new church was built on West Broad and Charles Streets in 1912. (Courtesy of John Cochran.)

This is the Mattie C. Redd Circle of Butler Presbyterian Church with Pickens A. Patterson, their new pastor, in 1948, at the old church at East Broad and McDonough Streets. Seen from left to right are Dorothy Washington, Thelma Thomas, Willie Mae Patterson (wife of pastor), Lucinda Brown, Lollie Orr, Cortez Cowart, Pickens A. Patterson, Edith Carter, Valencia Ruthledge, Eunice Washington, Agatha Cooper, Hattie Scruggs, Eunice Simmons, and Violet Singleton. (Courtesy of Willie Mae Patterson Freeman.)

The new Butler Presbyterian Church was built and dedicated in December 1954. Pickens A. Patterson Sr. pastored the church from 1948 until his death in 1980. He received his bachelor of arts and bachelor of sacred theology degrees from Lincoln University in Pennsylvania, and was the first black Savannahian to serve on the Housing Authority; he later became the chairman. Patterson was a state vice president of the NAACP. (Courtesy of Willie Mae Patterson Freeman.)

The groundbreaking ceremony for the new Butler Presbyterian Church at 603 West Victory Drive took place in 1954. Seen from left to right are Eric Washington, Elder J.E. Jackson, Elder Lee Davis, Elder Beatrice Colvin, Elder Ella Singleton, and Rev. Pickens A. Patterson Sr. (Courtesy of Willie Mae Patterson Freeman.)

William L. Cash was born in 1872, received an A.B. from Fisk University, and his B.D. from Oberlin Theological Seminary in 1905. He was ordained in 1905 and became pastor of First Congregational Church, serving almost 20 years as pastor. (Courtesy of *History of American Negro*, Georgia Edition, Volume II, 1920.)

Nathaniel M. Clarke was born in Jamaica in 1871, and attended Calabar College there. He came to Boston in 1900, matriculated at Lincoln University in Pennsylvania, and received an S.T.B. in 1906. He became the pastor of Beth Eden Baptist Church in 1912. (Courtesy of *History of the American Negro*, Georgia Edition, Volume II, 1920.)

St. Mary's Church and School were founded in 1907 by Father Ignatius Lissner, S.M.A. In 1917, he founded the black order Franciscan Handmaids of the Most Pure Heart of Mary at St. Mary's Church on West 36th Street. Many prominent black Savannahians attended the school as children. (Courtesy of Charles J. Elmore.)

St. Benedict the Moor Catholic Church is the oldest black parish in Savannah, established in 1874. The parish opened the first Catholic school for blacks in 1875. The Franciscan Sisters opened St. Benedict the Moor School in 1907, and operated the school until 1969, when a racially integrated Catholic school system was developed in Savannah. (Courtesy of Pauline E. Elmore.)

Mother Mary Theodore Williams was the First Superior General of the Franciscan Handmaids of the Most Pure Heart of Mary (1917). At 19, she entered the Sisters of Saint Francis, founded by a Marist priest, but the group was disbanded. Father Ignatius Lissner petitioned and was granted permission from Bishop Benjamin J. Keily, D.D., Savannah, to begin a seminary and religious community for black women. (Courtesy of Pauline E. Elmore.)

Gustave M. Caution received his A.B. from Lincoln University in Pennsylvania and a B.D. from Philadelphia Divinity School in 1922. From 1932 to 1939 he served as rector of St. Stephens Episcopal Church in Savannah. He enlisted as a chaplain and served in the U.S. Army during World War II. Caution returned to Savannah where he raised $80,000 to unify St. Stephens and St. Augustine churches as St. Matthews Episcopal Church in 1948. (Courtesy of Savannah State University Archives.)

Four
EDUCATION

Pictured here on August 9, 1918 are summer school students at Cuyler Street School. The school was built in 1914 as the first modern public school building for blacks in Savannah; John Wesley Hubert was the first principle. Pictured on the front row are Robert W. Gadsden (second from the left) and Lizzie Ervin (last person from the left). On the back row, from left to right, are Florence Ervin Robinson, Cornelia McDowell, Mag Woodard, Madeline Shivery, Mrs. N.H. Clark, Beatrice Stiles, Edna Price Ashton, Amanda Parker, Lucille Blackshear, Laurie Baker, Lorraine Kinkle, Harriet Brown, Veronica Beasley Arnold, and the rest are unidentified. (Courtesy of Samuel C. Parker Jr.)

Beach Institute was founded after the Civil War under the auspices of the American Missionary Association in 1867 with a gift of $10,000 from Alfred Ely Beach, founder of *Scientific American*. In 1914, it was the only school where a black Savannahian could complete 12 grades. It became part of the public school system in 1917.

This is an announcement for the 1922–1923 school year at Haven Home School. The school was founded in 1882 with the purpose of educating African-American girls. It was named for Methodist Bishop Gilbert Haven. The Women's Division of Christian Service, Methodist Episcopal Church, established the school. Mrs. G.E. Palen of Philadelphia secured funds to start the small school in the parsonage of Asbury United Methodist Church. (Courtesy of Roderick Steele Family.)

Children are pictured in a classroom at Harris Street School in 1946. The school was located in the Beach Institute building. (Courtesy of Ralph Mark Gilbert Civil Rights Museum.)

This is the Cuyler Street School faculty, c. 1938. Seen from left to right are (front row) Alice M. Ellis, Lizzie Simmons, Dorothy Ury, Ida B. Jenkins, Ella Parkhurst Law, John Wesley Hubert (principal), Stella Jones, Madeline Shivery, Nellie Coppage, and Lizzie E. Hendrickson; (middle row) Fannie DeVeaux, Eloise Holmes Harper, unidentified, Maude Patterson, unidentified, Juanita Baisden, Carrie Gaston, Cornelia McDowell, Ms. Taylor, and Mary Wright; (back row) Nathaniel Dunmore, unidentified, Hercules Leake, Herman Simmons, John Q. Adams, Otha L. Douglass, Philip W. Cooper, Joseph Green, Herbert Hardwick, William Mann, and John H. Law Jr. (Courtesy of Samuel C. Parker Jr.)

Beach Senior High School's graduating class of 1937 pose for a photograph in June of that year. John W. Hubert, principal, is the first person on the extreme left in the fifth row. Some of the members identified are Laura Densler (first row, last on the right), Lillian Shanks (sixth from the left on the third row), Norman B. Elmore (third from the left on the fourth row), and Frederick Owens (fifth from the left on the fourth row). Frank Blackshear and Bingley S. Hannah were also members of this class of 58 students. (Courtesy of Louise L. Owens.)

This is the 1943 graduation class of Cuyler Senior High. Class members are, from left to right, (first row) unidentified, Marion Simmons, Ludella Arkwright, Gwendolyn Handy, Evelyn Williams, Laura Derrick, Nellie Jones, Ludell White, unidentified, Mamie Pleasant, and Ethel Simmons; (second row) Viola Bacon, Henrietta Malone, Wilhelmena Eason, unidentified, ? Spaulding, ? Spaulding (sisters), Annie Mae Sams, Juanita Lavender, and two unidentified; (third row) Matthew Southall Brown, John White, unidentified, Virginia Luten, Annie Lee Ledbetter, Sarah Blyler, Catherine Bogan, Eva Mae Baker, Earl DeVeaux, and unidentified; (fourth row) two unidentified, Ernest Green, Fred Chapman, Raleigh Bryant, John Shepard, Douglas Jenkins, unidentified, and Paul Hubert. (Courtesy of John White.)

A faculty meeting is pictured in the new Alfred E. Beach High School Auditorium in 1950. Seen on the first row, from left to right, are Otha L. Douglass (principal), Alphonso McLean, unidentified, and Norman B. Elmore. On the second row, the fourth person on the right is Lester B. Johnson Jr. and Dorothy Lampkin is seated to his right. (Courtesy of Orion L. Douglass.)

The 1954 Beach High School varsity football team was coached by Joseph Green, standing on the extreme right at the end of the first row of players. (Courtesy of Orion L. Douglass.)

The 1960 faculty at Beach High School included, from left to right, (first row) Wilhelmena Dean, Marguerite K. Law, Johnnie Burke, Kay Stripling, Mattie Gray, Otha L. Douglass (principal), Oliver Lumpkin (assistant principal), Ella P. Law, Mattie B. Payne, Esther Harden, Janie Blake, Rosalee Williams, and Bessie Hardwick; (second row) Lester B. Johnson Jr., Stella Reeves, Willie Mae Patterson, Miriam Wilkerson, Lydia Mabry, unidentified, Dorothy Lampkin, Marilyn Jackson, Azelma Mobley, Erma K. Williams, Julia P. Simmons, and Frances Waddell; (third row) Vernon Rhaney, John H. Law Jr., unidentified, John Levy, Charles Johnson, Charles Gardner, Alphonso McLean, Daniel Wright, Nathaniel Harris, R.A. Moore, Virginia Wynn, Clarence Smith, Alethia Hamilton, Peter Smalls, and Frederick Glover. (Courtesy of Orion L. Douglass.)

Virginia Edwards graduated from A.E. Beach High School and Savannah State College in the 1960s. She received a master's degree in education from Armstrong State College, and an education specialist degree from Georgia Southern University. Mrs. Edwards served as a teacher, assistant principal, principal, and deputy superintendent. In 1998, she was appointed superintendent of Chatham County Public Schools, the first black Savannahian and second African American appointed. (Courtesy of Virginia Edwards.)

This is the 1933 junior high graduating class at St. Benedict the Moor Catholic School. In 1933, ninth grade was the highest grade an African-American child could reach in Catholic education in Savannah. (Courtesy of Louise L. Owens.)

The historic first graduating class of St. Pius X Catholic High School is pictured in 1955. St. Pius was the only coed Catholic high school in Savannah's Catholic history. The school opened September 6, 1952. The members of the first graduation class, pictured with Father M.B. Burke (principal) and Sister Donat, were Bernie Adams, Lillian Bradshaw, Emily Brown, Mabel Carter, Marjorie Delida, Rex DeLoach, Constance Mazo, Timothy Myers Jr., Mary Nelson, John Palmer, Mary Porter, Alphonso Reynolds, Carlton Russell, and Joseph Walthour Jr. The school closed in 1971 because of integration, but produced doctors, lawyers, educators, entrepreneurs, and an Associate Supreme Court Justice. (Courtesy of Rex DeLoach.)

A 12th grade chemistry class at St. Pius X High School is seen in 1963. Class members were, from left to right, (front row) Floyd Adams Jr., Mamie Moore, and William Freeman; (second row) Willie Shellman, unidentified, and Ulysses Benjamin; (third row) Alma Hooks and Wilbur Tyndal; (fourth row) Evelyn Sharpe and Ormonde Lewis; (fifth row) Sister Antoinette Sheridan (standing), unidentified, and Sam Morgan Jr.

Floyd Adams Jr., a 1963 graduate of St. Pius X, was elected Savannah's first African-American mayor. Mayor Adams attended Armstrong State College and Brooklyn College. He worked with his father, Floyd Adams Sr., publisher of the *Savannah Herald*, and became publisher of the paper in the 1970s. He served 12 years as an alderman and alderman-at-large in Savannah. Adams was elected mayor in 1996, and won his second term, unopposed, which ends in 2004. (Courtesy of Mayor Floyd Adams Jr.)

The 1964 St. Pius X Class A Basketball State Championship team was a first in the school's history. Pictured from left to right are (front row) James "Booney" Bryant, Leon Wendell Cooper, Elbert "Danny" Brown, Ronald "Drunker" Williams, and Orion L. Douglass; (back row) William Earl Fonvielle (trainer), George Singleton, Joey Williams, Ernest "Chubby" Harden, Rudolph Payton, James Guest, and Eddie Sampson (trainer). The team defeated Carver High School by a score of 64 to 57 for the championship. (Courtesy of Orion L. Douglass.)

Orion L. Douglass, a 1964 St. Pius X graduate, received his A.B. degree in philosophy from College of the Holy Cross; he received a J.D. from Washington University in St. Louis, Missouri. From 1981 to 1992, Douglass served as a municipal court judge in Brunswick, Georgia (Glynn County). In 1992, he was elected state court judge in Glynn County. Currently, he is serving a third term as judge of Glynn County State Court. (Courtesy of Orion L. Douglass.)

Clarence Thomas (left) and Richard Chisholm (right) are pictured serving mass as alter boys in 1963 when Clarence Thomas was enrolled as a freshman at St. Pius X High School. Richard Chisholm would graduate from St. Pius X in 1968. (Courtesy of Leola Williams.)

Clarence Thomas, Associate Justice of the U.S. Supreme Court, left St. Pius X, after one year, to attend St. John Vianney Minor Seminary in Savannah; he graduated in 1967. Thomas attended Conception Seminary, 1967–1968, and graduated cum laude from Holy Cross College. He then attended Yale Law School, graduating in 1974. Justice Thomas was Chairman of the U.S. Equal Opportunity Commission (1982–1990) and was appointed on March 12, 1990, to the U.S. Court of Appeals, District of Columbia Circuit, by President George Bush. He was nominated by President George Bush as Associate Justice of the United States Supreme Court and took office October 23, 1991. (Courtesy of Associate Justice Clarence Thomas.)

Savannah State University was founded as Georgia State Industrial College on November 26, 1890. The college moved permanently to Savannah on October 8, 1891, when Richard R. Wright Sr. arrived as first president with eight students from the Edmund Asa Ware High School in Augusta, Georgia, five faculty members, and a foreman of the farm. Pictured here is Richard R. Wright Sr., surveying the college farm in 1905. (Courtesy of Savannah State University Archives.)

(*left*) Richard R. Wright Sr. was born a slave on May 16, 1855, in a log cabin six miles from Dalton, Georgia. He graduated in June of 1876, with an A.B. in Classics and as valedictorian of the first college class of Atlanta University. He also received his A.M. there in 1879. Wright served as the first president of what is now Savannah State University, from 1891 to 1921. During his administration, students and faculty built Walter B. Hill Hall (1901). (Courtesy of *History of the American Negro*, Georgia Edition, Volume II, 1920.)

(*right*) Richard R. Wright Jr. was the first baccalaureate degree graduate from Georgia State Industrial College in June of 1898—the only member in that class. He received an M.A. degree in sociology from the University of Chicago in 1903, and was the first African American to receive Ph.D. in sociology from the University of Pennsylvania in 1911. Wright served as president of Wilberforce University and editor of the A.M.E. *Christian Recorder*. At the time of his death in 1969, he was the oldest bishop in the A.M.E. church. (Courtesy of Savannah State University Archives.)

Pictured here is the Georgia State Industrial College military band and corps of cadets *c.* 1905. (Courtesy of Savannah State University Archives.)

This is the faculty of Georgia State Industrial College, *c.* 1911. Seen from left to right are (front row) two unidentified, Lewis B. Thompson, Richard R. Wright Sr., Decatur Suggs, and unidentified; (back row) unidentified, E.M. Wilson, unidentified, J.G. Lemon?, two unidentified, and Samuel Grant. Boggs Hall, the original campus building, is seen in the background. Lewis Buchanan Thompson, son-in-law of Richard R. Wright Sr., married Essie Wright. He was the director of manual training and directed the construction of Walter B. Hill Hall in 1900–1901 (Courtesy of Savannah State University Archives.)

Walter Bernard Hill Hall, named after Chancellor Hill of the University of Georgia, was erected in 1900–1901 by faculty and students under the direction of Lewis B. Thompson and Joseph Hines. This building is on the national register of historic places, and is a landmark recognized by the Georgia Historical Society. It is the oldest building on Savannah State University's campus. (Courtesy of Savannah State University Archives.)

Pictured here is the 1922 faculty of Georgia State Industrial College, the first to serve under Cyrus G. Wiley. A member of the Class of 1899, Wiley was the first graduate to become president. Seen from left to right are (front row) F.A. Curtwright, Anna M. Blount, Cyrus G. Wiley, W.P. White, and F.R. Lampkin; (middle row) F.R. Flipper, J. Frank Rogers, Mamie Williams, Antonio Orsot, and R.M. Cooper; (back row) W.E. Tibbs, J.W. Derrick, Howard Jackson, John A. Lockette, Philander Moore, and Samuel L. Lester. (Courtesy of Savannah State University Archives.)

This is the freshman class at Georgia State Industrial College High School on May 3, 1922. Pictured from left to right are (first row) Margaret Scott, Evelyn Carlton, Norma Major, Thelma Postell, Prof. J.R. Lampkin, Frances Noble, Olive Shuman, Elsie Cooper, Rebecca White, and Helen Moring; (second row) E. Ison, Ernest Wilson, Edward Green, Miles Hall, Ellen Dowse, William Mallard, Emma Dowse, Felix A. Curtwright, John H. Law, Clarence Wright, and William Sanders; (third row) James Barnes, John Gary, Festus Flipper, B.J. Hopson, Herbert Miller, Amos Fields, Thomas Simmons, William Blakney, William Gladden, Millard Mack, Beauford McIver, Wesley Myers, Unavista Reid, and Aaron Ponhill; (fourth row) Samuel Sutton, Oliver W. Bryant, Raymond Wiggins, John Moody, Samuel Ferguson, Daniel Carter, John W. Cunningham, and John King. (Courtesy of Savannah State University Archives.)

Pres. Cyrus G. Wiley is pictured with the 1923 graduating class of Georgia Industrial College High School. (Courtesy of Savannah State University Archives.)

These are the members of the 1939 *Hubertonian* yearbook staff of Georgia State College. The *Hubertonian* was named after Benjamin F. Hubert, president of the college. (Courtesy of Louise L. Owens.)

Norman B. Elmore Sr. graduated from Georgia State College in 1941. He received his M.A. from Atlanta University in 1950, and his education specialist degree from New York University in 1962. Elmore taught in Millen, Georgia from 1941 to 1950, and taught biology at Beach High in Savannah from 1950 to 1953. He was principal of Maple Street School (1953), Robert W. Gadsden School (1955), and Florence Street School (1957–1979). He married Pauline E. Williams and had five children— Norman (deceased), Irene, Charles, Paul, and Clara. Four children graduated from Savannah State College. (Courtesy of Charles J. Elmore.)

65

Benjamin Franklin Hubert served as president of Georgia State College from 1926 to 1947. He was instrumental in developing the Girl Scouts of America movement for African-American girls in Savannah. Mrs. Louise L. Owens and Mrs. Mattie B. Payne (wife of Dean W.K. Payne) were also instrumental in developing the first African-American Girl Scout Troop in Savannah. (Courtesy of Savannah State University Archives, Louise L. Owens.)

William K. Payne, Savannah State president, presents the first-place SEAC Tournament trophy to Savannah State's women's basketball team, including (from left to right) Dorothy Baldwin, Gwendolyn Keith, Barbara Matthews, Martha Rawls, Neta Staley, Rosa Lee Moore, Eloise Cainion, Francie Howard, Ella W. Fisher (head coach), Clara Bryant, and Elnora Wright. The team was undefeated in 1953–1954. (Courtesy of Savannah State University Archives.)

James A. Colston, president of Georgia State College 1947–1949, modernized the campus, installed telephones in faculty offices, started the Campus Chest, organized the first department of public relations (1947), and hired Wilton C. Scott as director. After his tenure at Georgia State College, he became a college president in New York. (Courtesy of Savannah State University Archives.)

These are the members of the 1902 graduating class of Georgia State Industrial College, third coed class. Seen from left to right are (front row) James L. Allen, W.B. Mackiel, W.W. Allen, H.A. Houston, J.B. Watson, and Peter Cosey; (middle row) Eliza Sengstacke, Lillian M. Wright, Bertha D. Williams, Diana Daniels, Mattie Stringer, Anna M. White, Iona Coston, and Gertie L. McIntosh; (back row) C.W. Prothro, James Stringer, Anna T. Heyward, Decatur Suggs (vice president of college), Henrietta J. Pope, President R.R. Wright Sr., Clara Rogens, B.F. Lawton, Henry C. Scarlett, Charles A. Green, and J.H. Clarke. (Courtesy of Savannah State University Archives.)

67

William K. Payne became the fifth president of Georgia State College on September 14, 1949. He joined the college in 1937 and served as dean of instruction and faculty from 1940 to 1949. Payne received his A.B. from Morehouse College and his M.A. from Columbia University. During his tenure, the college's name was changed to Savannah State College in 1950, and was accredited by the Southern Association of Colleges and Schools in 1955. (Courtesy of Savannah State University Archives.)

The staff of Georgia Agricultural Extension Service at Savannah State College included, from left to right, (seated) Dora V. Martin; P.H. Stone, State Agent for Negro Work; Vera D. Brown; and Augustus Hill, Special Negro Agent for Rural Housing; (standing) A.B. Bacon, assistant supervisor; Alexander Hurse, State 4-H Club Agent; and K.C. Childers. (Courtesy of Savannah State University Archives.)

The 1921–1922 football team won the conference championship of the Georgia-Carolina League. The outstanding players in 1921–1922 were Benjamin McFarland, quarterback; Andrew Dago, halfback; and Dewey C. Belcher, halfback. (Courtesy of Savannah State University Archives.)

Seen from left to right are Daniel Nichols, Charles Ashe, Cecilio Williams, Richard Washington, Gilbert Jackson, Noel "Snuffy" Wright, William K. Payne (president, Savannah State College), Henry Praylo, James Meeks, Robert Lewis, Otis Brock, Clevon Johnson, and William Turner. President Payne receives the 1955 SEAC Tournament Championship trophy the men's basketball team won in March of 1955. (Courtesy of Otis J. Brock Sr.)

The "Chicago Five," coached by the legendary Theodore "Ted" Wright (1958–1962), compiled a 118-win, 15-loss record. The players were all recruited to Savannah State College from Chicago, Illinois. They won the SEAC conference championship four consecutive years, and the District 6-A NAIA title for three years. They are considered the greatest basketball team in the history of Savannah State University. Redell "Moose" Walton was the first All America basketball player at Savannah State. The "Chicago Five" included, from left to right, (front row) James Dixon and Stephen Kelley; (second row) Redell Walton, Willie Tate, and Ira Jackson. (Courtesy of Robert Mobley.)

Five
BUSINESS

Pictured is Royall Mortuary on West Broad Street, located in the Globe Theater, which was converted into a mortuary after it was built in 1917. (Courtesy of Frenchye and Frank Bynes.)

William Royall, born in 1847, was the first African American to own a mortuary in Savannah and was a captain of the Savannah Light Infantry (1877). He served as a deacon at First Bryan Baptist Church during the pastorates of Ulysses L. Houston and George Griffin. Royall died in 1905 and, by 1908, Lachlan M. Pollard became manager of the Royall Undertaking Company assisted by Paul J. Steele and W.H. Burgess. (Courtesy of First Bryan Baptist.)

Duncan J. Scott (in car) and Lachlan Pollard (standing) are pictured in the 1920s in a Royall Funeral car. Scott graduated from Fisk in 1903 and entered into business with Walter S. Scott, and was a pioneer in the scouting movement for blacks and the assistant manager of Royall Funeral Company. Lachlan Pollard was manager of Royall Company from 1916 to 1941. The son of William Pollard, he married Eleanor Scott Pollard (sister of Duncan and Walter Scott), and was the brother of Eliza Pollard DeVeaux. (Courtesy of Frenchye and Frank Bynes.)

Paul J. Steele, son of Louis Steele and Lucy Anna Powell Steele, received his license on January 11, 1909, from the Augusta College of Embalming. He worked with Royall Mortuary (1909), Savannah Undertaking (1920), and was in partnership with Sidney A. Jones before opening his mortuary in the 1920s on West Gwinnett Street. He ran Steele's Funeral Home on Houston Street for almost 40 years. Steele died on March 17, 1964. (Courtesy of Kana Mutawassim.)

Frank Bynes purchased Royall Mortuary in 1955 and re-named it Bynes-Royall Mortuary. He was a captain in the U.S. Army and married Frenchye Mason Bynes. Bynes-Royall Mortuary is the oldest black business in Savannah. (Courtesy of Frenchye and Frank Bynes.)

Frenchye Mason Bynes is the current director of Bynes-Royall Mortuary, and served 46 years as secretary/treasurer. She is currently assisted by Raleigh Bynes, her son, and other family members. (Courtesy of Frenchye and Frank Bynes.)

Louis B. Toomer organized Toomer Realty Company in 1923, and Georgia Savings and Realty Corporation, which became the Carver State Savings Bank in 1927. He started the Toomer Insurance Agency in 1937, was chairman of the Chatham County Republican Executive Committee, and was appointed Registrar of the United States Treasury by President Eisenhower for 1953–1956. Today, the bank is Carver State Bank. (Courtesy of Janie R. Toomer.)

Albert B. Singfield, born in 1876, worked with Pilgrim Insurance Company in Augusta at the age of 17. He became general superintendent (state of Georgia) for Pilgrim Insurance in the 1920s, and was Savannah district manager. Singfield served as a deacon at First Bryan Baptist; president of the Savannah District, State Young Peoples Baptist Union; and president of the Business League of Georgia. (Courtesy of First Bryan Baptist.)

Sol C. Johnson was born in Savannah on November 20, 1868, and attended West Broad Street School. In 1890, he became editor and manager of the *Savannah Tribune*. He purchased the newspaper in 1889 and erected a two-story office building on West Broad Street. He served as Worthy Patron of Eastern Star (1898) and as Grand Secretary of the Masons from 1895 to 1954. Sol C. Johnson High School is named for him. (Courtesy of *History of the American Negro*, Georgia Edition, Volume II, 1920.)

Albert H. Dunbar, born in 1873, came to Savannah in 1890 and worked almost 14 years on the Atlantic Coast Line and Central of Georgia Railroad. He was an agent with the Pilgrim Life and Health Insurance Company when he helped organize the Chatham Mutual Insurance Company of which he became the first president (1916). He was also a deacon of First Bryan Baptist Church. (Courtesy of *History of the American Negro*, Georgia Edition, Volume II, 1920).

Eugene H. Quo was born in 1871 and came to Savannah in 1905. He became president of the Fidelity Bank in the 1920s with total investments of $50,000. (Courtesy of *History of the American Negro*, Georgia Edition, Volume II, 1920.)

Ezra Johnson was born in 1893 and came to Savannah in 1898. He attended Haven Home (Savannah), Biddle University, and graduated from Hampton Institute in 1913. In 1902, he became a member of St. Philip A.M.E. Church. Johnson sold real estate while he worked for the U.S. Post Office until his retirement in 1952. He was vice president of A.F. King and Sons, and an active broker until age 90. He died September 29, 1993, at 99. (Courtesy of Rosemary Johnson Gordon.)

Pictured are Floyd Adams Sr. and Wilhelmena Anderson Adams. Floyd Adams Sr. founded the *Savannah Herald*, a weekly black newspaper in 1945. It is the oldest black weekly newspaper in Savannah. In the 1970s, Floyd Adams Jr. (now mayor of Savannah) became publisher of the newspaper. Currently, the newspaper is operated by Kenneth Adams and Kristy Adams Chisholm, the children of Floyd Adams Jr. (Courtesy of Kenneth Adams and Kristy Adams Chisholm.)

John W. Lyons attended Chatham County public schools and received a B.A. from Wilberforce in 1940. He owned John W. Lyons Real Estate and was a real estate/insurance broker from 1952 until his retirement. He was the first African-American member of the Savannah Historic Review Board, the Savannah Board of Realtors, and the Savannah Society of Real Estate Appraisers. (Courtesy of Merdis Jenkins Lyons.)

Joseph E. Fonvielle graduated from Howard University Pharmacy School in 1914. He and W.E. Moody purchased Savannah Pharmacy from Lee Chemical Company in 1915 with a loan from Wage Earners Bank. The business was located at West Broad and Maple. Eventually, the pharmacy had four stores in the chain. In 1952, J.E. Fonvielle was sole owner of the business. He was a member South Atlantic Medical Society, Charity Hospital Board, and the West Broad Street YMCA. (Courtesy of William Earl Fonvielle.)

Frances E. Fonvielle was an African-American female pioneer in the pharmacy business, serving as president of Savannah Pharmacy from 1955 to 1998. She was valedictorian (Class of 1939) of A.E. Beach High, salutatorian of Bennett College (1943), and received her pharmacy degree Howard University (1946). In 1965, she built a two-story office building on West Broad Street for the pharmacy. North Carolina Mutual and the Savannah Chapter of the NAACP were her tenants. (Courtesy of William Earl Fonvielle.)

William E. Fonvielle Sr. attended the public grade schools of Chatham County, graduated high school, and received his pharmacy degree from Howard University. He worked with his sister and father at Savannah Pharmacy from 1943 to 1955. (Courtesy of William E. Fonvielle.)

William E. Fonvielle Jr. graduated from St. Pius X High School in 1964 and received his B.S. degree from Miles College. He came to Savannah as secretary/treasurer of the Savannah Pharmacy (1974–1998) and assumed sole ownership of the pharmacy in 1998. Savannah Pharmacy is the second oldest black business in Savannah and remains the only black-owned pharmacy in the city. (Courtesy of William E. Fonvielle.)

T.J. Hopkins graduated from Georgia State Industrial College High School in 1918. He received his first B.S degree from Howard University in 1922, and another from Howard University in 1924 for electrical engineering. Hopkins was the first certified/bonded African-American electrical contractor in Savannah's history. He was a member of Omega Psi Phi Fraternity, and an active civic leader. (Courtesy of Savannah State University Archives.)

This is the office building of T.J. Hopkins, electrical contractor, at 1002 Montgomery Street. The photograph was taken in 1953. (Courtesy of Savannah State University Archives.)

Six
MEDICAL PIONEERS

Seated from left to right are the following members of Savannah's South Atlantic Medical Society, founded in 1904: Stephen McDew Jr., Richard Moore, Stephen McDew Sr., Julian Eberhardt, J.W. Jamerson Sr., W.A. Harris, unidentified, Fanin S. Belcher, Dr. Rolf (speaker from MeHarry Medical College), J.W. Jamerson Jr., Henry M. Collier Jr., M.P. Sessoms, N.H. Collier, E.J. Smith, Henry M. Collier Sr., M.D. Bryant, S.F. Frazier, and I.D. Williams Sr. (Courtesy of Ouida F. Thompson.)

Dr. Cornelius McKane was born in 1862 in British Guiana and graduated in 1891 from the University of Vermont Medical College. He came to Savannah in 1892 and married Dr. Alice Woodby. By 1896, they established the McKane Hospital on 644 West 6th Street (now 36th), the first Savannah hospital for blacks established by African Americans. Some of the trustees of the hospital were William Royall, Sol C. Johnson, and Dr. Simon P. Lloyd—the first black city physician in Savannah. (Courtesy of Charles J. Elmore.)

Dr. Alice Woodby, born in 1865 as a free person in Pennsylvania, received a medical degree in 1889 from the Women's Medical College of Pennsylvania. She went to Augusta in 1889 as a resident physician and instructor in nursing at the Haines Institute, where Lucy Craft Laney was president. Dr. Alice W. McKane founded the first nursing school for Savannah blacks in September 1893. While in Liberia, West Africa in 1895, the McKanes founded the first hospital there. The McKanes left Savannah in 1909. (Courtesy of Charles J. Elmore.)

Dr. Linton S. Parks, born in 1860, was the pioneer black dentist in Savannah, and the first African American to enter the profession in Georgia. In 1878, he came to Savannah, studied under Dr. A.H. Best (a white dentist), and opened his office in 1889. At one time, he had the largest African-American dental practice in Savannah. (Courtesy of *History of American Negro*, Georgia Edition, Volume II, 1920.)

Dr. William A. Harris, born in 1877, graduated from Georgia State Industrial College High School; received his B.S. from Lincoln University in 1900; and received his M.D. in 1906. He began practice in Savannah in 1911. Harris was president of South Atlantic and State Medical Societies and served on the staff of the Charity Hospital. (Courtesy of *History of the American Negro*, Georgia Edition, Volume II, 1920.)

Dr. William G. Tyson, son of Dr. C.B. Tyson, attended Cuyler School and received his M.D. from MeHarry Medical College in 1926. Dr. Tyson is shown with Laura King, public health nurse, attending an infant with the mother looking on. (Courtesy of Samuel C. Parker Jr.)

Dr. Isaiah D. Williams Sr. was born in 1879. He is pictured here with his family—wife Blanche C. Williams with daughter Margaret on her knee and I.D. Williams Jr. on his father's knee. Dr. Williams graduated from Dorchester Academy in Liberty County, Georgia. He then received his M.D. from MeHarry Medical College in 1907. (Courtesy of *History of the American Negro*, Georgia Edition, Volume II, 1920.)

Dr. Fannin S. Belcher was born in 1871 and attended Haines Normal and Industrial Institute in Augusta). He received his A.B. from Lincoln University in 1893 and his M.D. from Howard University in 1901. In 1902, he began his practice in Savannah and served as city physician for many years. He was president of the State Medical Association and a member of the South Atlantic Medical Society. His office was located on West Broad Street. (Courtesy of Ursuline B. Ingersol-Law.)

Born in 1872, Dr. Bartow W.S. Daniels graduated from Sparta High School and earned his A.B. at Atlanta Baptist College (now Morehouse College). Dr. Daniels received his M.D. at MeHarry Medical College in 1904. He began practice in Savannah in 1908, served as a city physician, and was a delegate to the 1916 Republican National Convention. (Courtesy of *History of the American Negro*, Georgia Edition, Volume II, 1920.)

Dr. J. Wilmette Wilson graduated from Talladega College and received his D.D.S. from the University of Iowa School of Dentistry in 1929. A pioneer in Savannah's black community, Dr. Wilson was a prominent dentist in Savannah for 51 years and member of American Dental Association. He married Martha Wright Wilson, mathematician and dean of Savannah State College (1939–1975). They had two daughters—Lois and Judith. (Courtesy of Lois Wilson Conyers and Martha Wright Wilson.)

Dr. John W. Jamerson Sr., born in 1874, received his A.B. from Biddle University (now Johnson C. Smith) in 1900 and his D.D.S. from MeHarry in 1905. He began his dental practice in Savannah in Wage Earners Bank on West Broad Street. Jamerson was a director of Wage Earners Bank. His son and grandson followed in his footsteps as dentists in Savannah. (Courtesy of *History of the American Negro*, 1920.)

Dr. John W. Jamerson Jr. was born in 1910 and received his A.B. from Lincoln University in 1933. He earned his D.D.S. at MeHarry in 1941. Jamerson was a plaintiff in a federal court lawsuit that eventually brought desegregation of Savannah's public schools. He was vice president of the Savannah NAACP for 25 years, and worked for 40 years in Civil Rights Movement. He was a captain in the Air Force during the Korean War, and a 50-year member of St. Matthews Episcopal Church. (Courtesy of Dr. John William Jamerson III.)

Born in 1951, Dr. John W. Jamerson III earned his B.S. at Savannah State College in 1974 and his D.D.S. at Howard University Dental School. He is a life-long member of St. Matthews Episcopal Church. Dr. Jamerson practiced dentistry with his father in the 1970s. He is secretary of the Southeast District of the American Dental Association, a life member of the NAACP, and vice chairman of the King-Tisdell Cottage Foundation, Inc. (Courtesy of Dr. John W. Jamerson III.)

Dr. Carl R. Jordan was born in 1924 in Savannah and graduated from A.E. Beach High School. After earning his B.S. from Howard University in 1946, Jordan went on to receive his M.D. from Howard Medical College in 1948. He served as a captain in the U.S. Army Medical Corps. He began practice in Savannah in 1949 and served as chief of surgery at Charity Hospital; he later founded the Jordan Clinic. He was a Fellow of American Society of Abdominal Surgeons and a member of the American Society of Colon and Rectal Surgeons. Dr. Jordan retired from medical practice in 1991. (Courtesy of Ann K. Jordan.)

This is a ward of the Georgia Infirmary Hospital in 1936. The hospital was founded in 1832 by whites for slaves who were ill and needed medical treatment and confinement. The first nurse on the left is Mary Grenade and second nurse on the left is Arizona Priester Brown. The nurse on the right is Suzanne Primus. The Charity Hospital, which evolved from the 1896 McKane Hospital, and the Georgia Infirmary were the only hospitals serving the medical needs of African Americans in Savannah until the late 1960s. (Courtesy of Samuel C. Parker Jr.)

Dr. Herbert L. Cooper, born in 1875, is pictured with his children: Standing on the left are Elsie Lee and Herbert Jr.; Wendell Phillips sits on his knee. Mrs. Ollie R. Cooper, his wife, died at a young age. Dr. Cooper received his M.D. from MeHarry Medical College and began practice in Savannah in 1911. (Courtesy of *History of the American Negro*, Georgia Edition, Volume II, 1920.)

Dr. Phillip W. Cooper, a Savannahian, graduated from Benedict College and received his D.D.S. from MeHarry Medical College School of Dentistry in 1950. He taught at Beach-Cuyler High School in the 1940s and was an elder of Butler Presbyterian Church. He is pictured here (with Rev. Pickens A. Patterson in the background) during the 1965 mortgage burning ceremony at Butler Presbyterian. Dr. Cooper opened his office in 1950, was married to Agatha Cooper, and had a son, Dr. L. Wendell Cooper, who received his D.D.S. from MeHarry School of Dentistry in 1975. (Courtesy of Willie Mae Patterson Freeman.)

Seven
Clubs and Jazz

Albert "Al" Cutter and the "Snappy Six" Band are seen here in the 1930s. Pictured fourth from the left is Al Cutter; sixth from the left is Robert Gill. Al Cutter graduated from Georgia State Industrial College in 1930 where he played in the college band. By 1926, he organized the "Snappy Six." Some of the players were Clarence Brooks, Larry Noble, Clarence Smith, and Joe Smith. The band was the most popular jazz band in Savannah in the 1930s and 1940s, and toured extensively throughout the South. (Courtesy of Charles J. Elmore.)

The Mutual Benevolent Society was founded in January of 1876. Pictured are members of the Mutuals in the 1930s, including (first table from left, sitting) unidentified, Walter Bogan, and John Starr; (first table, right side, sitting) Sergeant Howard, unidentified, John Lyons Sr., unidentified, Harry Miller, Lawrence Sales, and unidentified; (second table, left side) Johnny Gadsden, Alphonso Roberts, Boo Hardwick, Roland Geiger, unidentified, and Samuel C. Parker Sr.; (second table, right side, sitting) three unidentified, Earl Edwards, William Solomon, Frank Curley Jr., and Sam Brown. Standing around the room from left to right are Sear Hardwick, ? Smith, S.F. Frazier, Frank Callen, Lester Johnson Sr., Frank Dilworth Sr., T.J. Hopkins Sr., Paul E. Perry, four unidentified, Julian Eberhardt, and I. Damon Williams. (Courtesy of Merdis Lyons.)

The Mutuals Dance included music by the Snappy Six Band. Notable Savannahians present included the following: (women) Ernestine Taylor, Alice McKelvey, Mamie Edwards, Nona Hopkins, Frances McNichols, Esther Warrick, Lucille Johnson, Rebecca Curley, Harriet Brown, Amanda Parker, Susan Perry, and Pearl Steele; (men) J.W. Wilson, T.J. Hopkins, Earl Edwards, William McKelvey, Paul J. Steele, Harry Miller, Boo Hardwick, Medicus Simmons Sr., Johnny Gadsden, Frank Callen, and Frank Curley. (Courtesy of Merdis Lyons.)

The Wolves Club, Inc., founded in 1924, is the second oldest black men's club—after the Mutuals—in Savannah. The Wolves are pictured in the 1940s. From left to right are Martin G. Haynes, J. Wilmette Wilson, Herbert N. Hardwick, E. Sim Thomas, Eugene Weathers, Samuel C. Parker Sr., Lester B. Johnson Sr., Alfred Alston, Willie M. McNeil, Joseph M. Green, and William G. Tyson. (Courtesy of the Wolves Club, Inc.)

The Wolverines, wives of the Wolves, are pictured in the 1940s. Seen from left to right are Mrs. Lester (Lucille) Johnson, Mrs. Herbert (Johnny Mae) Hardwick, Mrs. Sim (Lucile) Thomas, Mrs. Martin (Mamie) Haynes, Mrs. Eugene (Helen) Weathers, Mrs. Wilmette (Martha) Wilson, Mrs. Joseph (Eldora) Green, Mrs. Willie (Dora) McNeil, Mrs. Bill (Maude) Tyson, Mrs. Sam (Amanda) Parker, and Mrs. Al (Edna) Alston. (Courtesy of the Wolves Club, Inc.)

The Allegros Club was founded on December 27, 1936. Pictured here, c. 1947, from left to right are (front row) Edward Nelson, Henry O'Brien, James Drayton, Earl Ashton, George White, and Ralph Brown; (back row) Duncan J. Scott Jr., James Fisher Jr., James Mack Roberts, Thomas S. Beaton, Samuel C. Parker Jr., and Samuel J. Brown Jr. (Courtesy of Samuel C. Parker Jr.)

The Dunbar Theater was built by the Savannah Motion Picture Corporation, a $100,000 African-American corporation led by Walter S. Scott. Located on 467 West Broad Street, the theater opened in 1921. *Symbol of the Unconquered*, a movie by Oscar Micheaux, a pioneer black movie producer, was the first film shown at the Dunbar.

The Melody Theater opened in 1946 on East Broad Street and was the first new African-American movie house built since the Dunbar Theater in 1921. It was the first air-conditioned movie theater for blacks in Savannah, and headlined bands such as Jimmy Lunceford and other jazz and blues stars of the 1940s and 1950s.

Theodore "Ted" Pollen Sr. along with Clarence Walker organized the Syncopated Six orchestra in 1921 and the Harmony Five in 1922. By 1925, he developed the Yum Yum Five band. His band was the house band at the Dunbar Theater during the 1920s. The band toured extensively in the Southeast, and regularly played live on WTOC radio in the 1930s. (Courtesy of Ted Pollen Jr.)

Mamie Steele Cox (left) and Jeremiah "Jerry" Cox are pictured with Marie Dressler (center), the movie star. They worked for Dressler as a housekeeper and chauffeur for 25 years in New York and California. Marie Dressler left the couple $50,000 in her will. They returned to Savannah and opened the Coconut Grove, a pioneering jazz club, on April 11, 1936. The club featured the Snappy Six and jazz bands until the 1960s. (Courtesy of Kana Mutawassim.)

Thomas W. "Pops" Scott Jr. was born in 1904. He pioneered the use of the bass violin as a jazz instrument in Savannah jazz from the late 1920s until the 1960s. "Pops" Scott was a seminal force in the evolution of Savannah jazz, playing with Al Cutter's famous Snappy Six jazz band. When he died in July 2001, Scott was the oldest jazz pioneer living in Savannah. (Courtesy of Ethel King.)

Thomas W. "Thurlow" Scott III was the only son of "Pops" and Alzada Scott. Between 1940 and 1943, he played jazz in San Francisco while in the U.S. Navy. Thurlow played with Kenny Palmer, Sam Gill, "Buby" McMillian, and Phineas Newborn Jr. He was one of the pioneers of bebop and bass fiddle in Savannah's jazz scene for over 20 years. (Courtesy of Ethel King.)

John "Tiny" Austin, saxophonist, fronted his own jazz band in the 1940s. He played in the local bands of Walter Langston, the John Curry Trio, and Bobby Dilworth and the Blazers. In his band, Austin had sidemen like Lucius Bryant, Ben Logan, and Joe Mandinburg (arranger for his band). Mandinburg, a saxophonist, played with Edith Curry's band before coming to Savannah. (Courtesy of John Austin.)

Samuel A. "Sam" Gill Jr. was one of the most important trumpeters in Savannah's jazz history. He began playing trumpet in 1935, and was taught music by Robert Gill, his older brother. In the late 1930s, he played with the Snappy Six band. In the 1940s he played with Noble Sissle and Cab Calloway, and toured the South with Edith Curry's Jazz Band. He was a 1947 graduate of Georgia State College (now Savannah State University). (Courtesy of Samuel A. Gill III.)

Irene Redfield Reid graduated from A.E. Beach High School and went to New York at an early age. She won the amateur contest for five consecutive weeks at the Apollo Theater in New York. Reid was the vocalist for the Dick Vance band in New York (1948–1950). She sang with Count Basie (1961–1962) and has recorded over 10 albums since 1962. She continues to sing jazz and blues in New York and in Europe. (Courtesy of Teddy Adams.)

Lucius Bryant played drums with Art Foxo in the 1940s in Boston. He played Boston's Wally's jazz club and was known as one of Boston's premier jazz drummers. Bryant returned to Savannah in 1954, and opened the Lucius Bryant School of Drumming on West Broad and Gaston Streets. (Courtesy of Teddy Adams.)

Samari Celestial (Eric Walker) was a polyrhythmic percussionist who could play "inside" and "outside" the music. His 10-year association with Sun Ra, as percussionist, included 15 CDs and cassettes. With Sun Ra, he toured South and North America, the Middle East, Japan, and Europe. (Courtesy of Teddy Adams.)

Edward "Eddie" Pazant played saxophone for 11 years with Lionel Hampton's band. He teamed with his brother Alvin, to form the Pazant Brothers Band (Beaufort Express). He has accompanied such greats as Cab Calloway, Ben Vereen, Eartha Kitt, and Della Reese. Pazant spent six years playing for Melba Moore. (Courtesy of Teddy Adams.)

Estella Jackson Storms graduated from A.E. Beach High School and sang with Joe Bristow's Tenderly Band in the 1950s in Miami Beach. In Miami, she performed with the C Major Quintet, which included Blue Mitchell on trumpet. In Savannah, she performed with the Clay White Band, Bobby Dilworth and the Blazers, and the James Wiley Trio. She also performed at the fabled Flamingo Club in Savannah. (Courtesy of Teddy Adams.)

Ben Riley, in the late 1950s and 1960s, played drums with Sonny Rollins, Sonny Stitt, Stan Getz, Eric Dolphy, Woody Herman, Kenny Burrell, Eddie "Lockjaw" Davis, Nina Simone, and Ahmed Jamal. He did a four-year stint (1964–1967) as Thelonius Monk's regular drummer and recorded with him. (Courtesy of Teddy Adams.)

John "Teddy" Adams is a Savannah jazz pioneer, who began to play professional jazz trombone at 14. From 1956 to 1960, he played with the Blazers, Clay White, James Drayton, and Walter Langston. While in the U.S. Air Force band in Asia, Adams played with Bobby Timmons, Sadao Wantanabe, Blue Mitchell, and Art Blakney. He has performed in all 18 of Savannah's jazz festivals. He is a co-founder of the Coastal Jazz Association. (Courtesy of Teddy Adams.)

Willie Draper graduated from A.E. Beach High School in 1945 and left Savannah in 1948 to play with Pete Diggs big band. He went to Cleveland, where he played tenor saxophone with Tommy and Stanley Turrentine. He played locally with Theodore "Stubby" Mitchell and Joe Bristow. Draper wrote music for Otis Redding and toured with him in 1960s. (Courtesy of Teddy Adams.)

Matthew "Buby" McMillian came to Savannah in 1949, after he played tenor saxophone with Nat King Cole, the Mills Brothers, Tony Cantina, and Walter Johnson. He remains a cornerstone of the local jazz community and is a member of the Savannah Jazz Orchestra. He has played with every major musician in Savannah's storied jazz history. (Courtesy of Teddy Adams.)

Theodore Clinton "Stubby" Mitchell, (center of picture, left) is seen with Teddy Adams and Matthew "Buby" McMillian. Mitchell, a trumpeter, has been on the Savannah jazz scene since 1942. As a soldier in the 1940s, he sat in with Buddy Johnson's band. He met Jimmy Lunceford in 1947, but refused an offer to play with his band. Mitchell played with the Stanley Williams Band in Chicago. He has played jazz in Savannah for over 50 years. (Courtesy of Teddy Adams.)

Joseph A.E. "Joe" Steele, a pianist, had a 1920s band in New York, which included, at various times, Ward Pinkett, Langston Curl, Bubber Miley, Johnny Hodges, and Harry Carney. He arranged music, recorded, and played piano with Chick Webb in the 1930s. Steele played in Lew Leslie's *Rhapsody in Black* (1931) in Boston. He arranged music for the big bands of Duke Ellington, Fletcher Henderson, Paul Whiteman, and Cab Calloway. (Courtesy of Charles J. Elmore.)

Benjamin Mayer "Ben" Tucker played bass in California in the 1950s with Chico Hamilton, Art Pepper, Frank Rossilini, and Shorty Rogers. Tucker played at the Hickory House with Marian McPartland (1960–1968) and with Billy Taylor and Grady Tate. He has recorded with Gerry Mulligan, Illinois Jacquet, Herbie Mann, and many others. He composed the famous "Coming Home Baby," and played it with Herbie Mann at Newport in 1965. (Courtesy of Ben Tucker, Paul Nurnberg.)

The Preacher and the Deacons included, from left to right, Willie T. Williams, alto saxophone; David Wright, drums; Lee Fluker, bass; Addie Mae Frazier, piano; and James "Sonny" Hawkins, tenor saxophone. They are pictured at the Den Club in 1960. (Courtesy of Willie T. Williams Jr.)

The James Wiley Trio included the following players, from left to right: James Wiley, Aubrey Mumford, three unidentified, Sam Early (guest performer), and Ben Logan. The James Wiley Trio was the first African-American jazz trio to appear on Savannah television, and appeared during the season as the in-house band at the famous Black Orchid Lounge on Miami Beach. (Courtesy of Aubrey Mumford.)

The James Drayton Band (1946) was made up of the following musicians, from left to right: (front row) unidentified, Bobby Dilworth, saxophone; and Carl P. Wright, trumpet; (back row) John "Basie" Allen, bass; unidentified, drummer; James Drayton, piano; and A.B. Bryant, vocalist. (Courtesy of Teddy Adams.)

The Ted Pollen, Jr. Band (1955) boasted the following players, from left to right: Theodore "Ted" Pollen Jr. on piano; Claude Roberts on drums; Matthew "Buby" McMillian on tenor saxophone; and Thurlow Scott on bass. They are pictured at the Stork Club. (Courtesy of Ted Pollen Jr.)

Tommy Smalls graduated from Savannah State College in 1950 and in 1952 he was recognized as New York's top African-American disc jockey. Starting in Savannah at WDAR-AM (a white-owned station) with "The Tommy Smalls Show" (1950), he became first black disc jockey in Savannah, and later joined WJIV. Smalls went to New York in 1951, was elected mayor of Harlem in 1956, and owned Smalls Paradise in New York. (Courtesy of Charles J. Elmore.)

Raymond "Ray" Snype organized the Golden Syncopators in 1930 and led the band for 12 years. His band combined with the Snappy Six band in early 1940s so they could play charts of Don Redman, Jimmy Lunceford, Duke Ellington, and Count Basie. Snype and Cutter's bands were the only local black bands to play Tybrisa on Tybee Island. Snype continued to play jazz until his death in 1993. (Courtesy of Margaret Gadsden Caution Snype.)

Bobby Dilworth and the Blazers (*c.* 1953) included Lafayette Chester, in front; Evelyn Brown, on piano; James "Keeptee" Worlds, on drums; Arthur Dilworth, on saxophone; Bobby Dilworth, on saxophone; and Jimmy Dilworth, on trumpet. (Courtesy of Teddy Adams).

Eight
THE CIVIL RIGHTS ERA

In 1963, the Fifth Circuit Court of Appeals ordered public schools of Savannah desegregated. Nineteen black students integrated the 1963–1964 twelfth-grade classes at Robert W. Groves High School and Savannah High School. Pictured here from left to right are (front row) Lillian Myers; Frankie Coleman; five unidentified; and Geraldine Loadholt; (back row) W.W. Law, president, Savannah NAACP; L. Scott Stell, chairman, NAACP Education Committee; Robert Stephenson; Ulysses Bryant Jr.; George Shinhoster; Sage Brown; Anistine Thompson; unidentified; Florence Russell; John Alexander; Robbie Robinson; Eddie Banner; and A.J. Scott, NAACP Executive Committee. The students that cannot be specifically identified include Georgia Ann Lawson, Martha Coleman, Delores Cooper, Ann Goldwire, Sadie Simmons, and Sara Townsend. (Courtesy of Ralph Mark Gilbert Civil Rights Museum; photo by Bob Mobley.)

This is the NAACP Century Club in 1942. Seated from left to right are Stella Jones Reeves and ? Daise; standing from left to right are Ralph Mark Gilbert, Joseph M. Green, and Boston Williams. Reverend Gilbert, president of the Savannah NAACP from 1942 until 1950, organized the Georgia Conference of NAACP and was its first president. He led the movement to establish the West Broad Street YMCA, the Greenbrier Center, and the first black policemen in Georgia. W.W. Law succeeded him as Savannah NAACP president in 1950. (Courtesy of Ralph Mark Gilbert Civil Rights Museum.)

W.W. Law, president of the Savannah Branch of the NAACP, is addressing a mass meeting rally at St. Philip A.M.E. Church on West Broad Street in 1960. (Courtesy of Ralph Mark Gilbert Civil Rights Museum.)

These persons had perfect attendance at NAACP mass meetings from March 20, 1960 to March 20, 1970. Seen from left to right are (front row) Geneva Wallace Law; Aurelia Jones; Addie Byrd Byers; Lottie Banner, NAACP Youth Advisor; and Margaret Bond Snead; (middle row) Viola Jones; Hattie Reynolds Mays; Izotta Edwards; Alice Baisden Hayes; and W.W. Law, NAACP president, Savannah Branch; (back row) James Carlege; Thomas Brown; Clyde Esther Garrison, NAACP Savannah Branch secretary; Clarence Edwards; and Willie Winters. (Courtesy of Ralph Mark Gilbert Civil Rights Museum.)

Pictured are first nine African-American members of the Savannah Police Department on May 3, 1947. Seen from left to right are John A. White, Leroy Wilson, W.N. Malone, Frank Mullino, Howard J. Davis, Milton Hall, James Nealy, Alexander Grant, and Stephen Houston. Standing with them is Lt. Truman F. Ward. (Courtesy of John White.)

A 1948 dinner hosted at Frank Callen Boys Club for black Savannah police officers included, from left to right, (standing) Connie "Pop" Wimberly, Frank Callen, Leroy Wilson, W.N. Malone, and William J. Day; (seated) Lucille Johnson, Lester B. Johnson Sr., Erma Callen, unidentified, Charlotte Curley, Albert "Chunky" Brooks Jr., Fay "Jazzbo" Patterson, Milton Hall, Stephen Houston, Howard Davis, James Nealy, W.N. Mullino, and W.E. Wallace. (Courtesy of John White.)

On May 1, 1947, Savannah hired its first black city employees—one police matron, four porters, and one city hall employee. They are all unidentified except Walter B. Leftwich (sixth person on the extreme right). Leftwich later worked as a mathematician, for over 25 years, at Savannah State College. (Courtesy of John White.)

In 1964, Otis S. Johnson (third row, fourth graduate from the left) was first African American to enroll and graduate from the previously all-white Armstrong Junior College (founded 1935). He was a member of the NAACP Youth Council, received his B.A. from the University of Georgia, his M.A. from Atlanta University, and his Ph.D. from Brandeis University in 1980. Johnson worked at Savannah State College from 1971 to 1988 and with the Youth Futures Initiative of Savannah from 1988 to 1998. Currently, he serves as dean of Savannah State University. (Courtesy of Otis S. Johnson.)

John B. Clemmons Sr. was head of the mathematics/physics department at Savannah State College for 37 years. During the Civil Rights Movement, he put up personal real estate holdings and monies to bail out protesters who dared challenge segregationist laws. He is also a pioneer in the Boy Scout Movement. John is married to Mozelle D. Clemmons and is the father of Dr. John B. Clemmons Jr. and Shelia Clemmons. (Courtesy John and Mozelle Clemmons.)

Mozelle Dailey Clemmons devoted 26 years to the Savannah Branch of the NAACP, serving as Chatham County vice president and also starting the NAACP Freedom Fund Dinner. Along with W.W. Law and Lee and Emma Adler, she helped preserve the King-Tisdell Cottage, and set up the King-Tisdell Foundation dedicated to preserving African-American heritage and artifacts. She was the first African-American member of the Georgia Historical Society Board of Curators and the Savannah Symphony Guild. (Courtesy of John and Mozelle D. Clemmons.)

Curtis V. Cooper graduated from Woodville High School in 1951, earned his B.S. from Savannah State College, and his M.P.H. from the University of Michigan. He was a member of the NAACP Youth Council; vice president of the Savannah NAACP; and succeeded W.W. Law as president in 1976. Cooper served as executive director of the Westside Urban Health Center from 1971 to 2000; was the first African-American board member of the Memorial Medical Center; and served as chairman of that board in 1975. He married Constance Hartwell Cooper and had two children—Curtis Victor Jr. and Constance Allyson. (Courtesy of Constance Hartwell Cooper.)

Benjamin F. Lewis received his B.S. from Savannah State College and his J.D from John Marshall Law College. He became a regular U.S. Postal Service employee in 1945. In 1963, he was appointed Equal Employment Opportunity Officer for the Savannah Post Office. In 1969, he was appointed Regional EEOO officer, assigned to Atlanta. That same year, he was the first African American in the 20th century appointed as foreman-supervisor of mail. In 1970, Lewis was appointed National Equal Opportunity Employment Specialist and assigned to Washington, D.C. (Courtesy of Benjamin F. Lewis.)

Wilton C. Scott (center), the founder/director of the Southern Regional Press Institute (SRPI) at Savannah State College (1951–1971), presents the 1965 Distinguished Service Award to Lawrence Walsh, the first editor of the *Pacemaker*, the SRPI newspaper, and editor of the *Duquesne Duke*. Walsh was the first white student to participate in the Press Institute. Louis J. Corsetti (to the right), *Pacemaker* advisor, was the first white consultant to SRPI and continues with the institute after 37 years of service (1964–2001). (Courtesy of Charles J. Elmore.)

L. Scott Stell was pastor of Bethlehem Baptist Church from 1952 to 1985. He was a civic leader and a plaintiff on the first lawsuit filed in Savannah/Chatham County to combat segregation in local schools (1959). He was elected in 1970 as the first African-American County Commissioner in the history of Chatham County, Georgia, and served several terms in the 1970s and 1980s. He worked with W.W. Law in successfully desegregating the public schools of Savannah and also served as chairman of the NAACP Education Committee. (Courtesy of Rev. Larry Stell.)

Westley Wallace Law graduated from Beach High School in 1942 and earned his B.S. at Georgia State College in 1948. Law is known as "Mr. Civil Rights," locally and nationally. He worked with the U.S. Postal Service as a letter carrier for 40 years. In the 1940s, he was president of the NAACP Youth Council, worked with Ralph Mark Gilbert, and was president of the Savannah NAACP from 1950 to 1976. Law was the leader of Savannah's Civil Rights Movement. He is also a nationally known preservationist, and one of the founders of the King-Tisdell Foundation, the Ralph M. Gilbert Museum, and the Beach Institute. (Courtesy of Steve Bisson.)

125

Bobby Lee Hill received his B.S. from Savannah State College in 1963; and his J.D. from Howard University Law School. He was a champion for Civil Rights of African Americans and successfully litigated many cases for their legal rights. He was the first African American to be elected to the Georgia Legislature (1969–1970) since 1868, when Ulysses L. Houston, James Porter, and James M. Simms were expelled. Hill represented the 94th, 110th, and 127th districts for 14 years. (Courtesy of *Savannah Morning News*.)

Clyde Esther Garrison was one of the first African Americans to serve on the Savannah/Chatham County Public Board of Public Education in 1965. She served on the Board of Education for 20 years and was known for her efforts to desegregate public schools. For 25 years she served as secretary of the Savannah Branch of the NAACP. Esther Garrison Elementary School is named in her honor. (Courtesy of *Savannah Morning News*.)

Bowles C. Ford was the first African American elected as alderman in Savannah (1970–1978). He was also the director of an African-American insurance company. Bowles C. Ford Community Park is named in his honor in Cloverdale Subdivision. (Courtesy of *Savannah Morning News*.)

Eugene H. Gadsden received degrees from Georgia State College and Lincoln University. He earned his J.D. from North Carolina Central University School of Law. He was the first African-American lawyer admitted to Savannah Bar Association and Savannah Chamber of Commerce. Gadsden successfully litigated many cases during the Savannah Civil Rights Movement and was the first black Savannahian appointed as judge of the Chatham County Superior Court in 1979. He won re-election to the post until he retired in 1992. (Courtesy of *Savannah Morning News*.)